MOTHER ARCHIVE

MOTHER ARCHIVE

A DOMINICAN FAMILY MEMOIR

ERIKA MORILLO

UNIVERSITY OF IOWA PRESS, IOWA CITY

University of Iowa Press, Iowa City 52242
Copyright © 2024 by Erika Morillo
uipress.uiowa.edu
Printed in the United States of America

ISBN: 978-1-60938-993-2 (pbk)
ISBN: 978-1-60938-994-9 (ebk)

Design by Nola Burger

Printed on acid-free paper

All photographs © Erika Morillo, unless otherwise noted. Photos on pages 17, 13, 18, 19, 51, 55, 67, 73, 83, 99, 119, 131, 149, 163, 177, 201, and 237 courtesy of Lourdes Echavarría. Photos on pages 22, 30, and 31 courtesy of the Archivo General de la Nación (AGD).

Cataloging-in-Publication data is on file at the Library of Congress.

To Abuela Eneida
and my son, Amaru,
the beginning and future of my lineage

CONTENTS

ONE

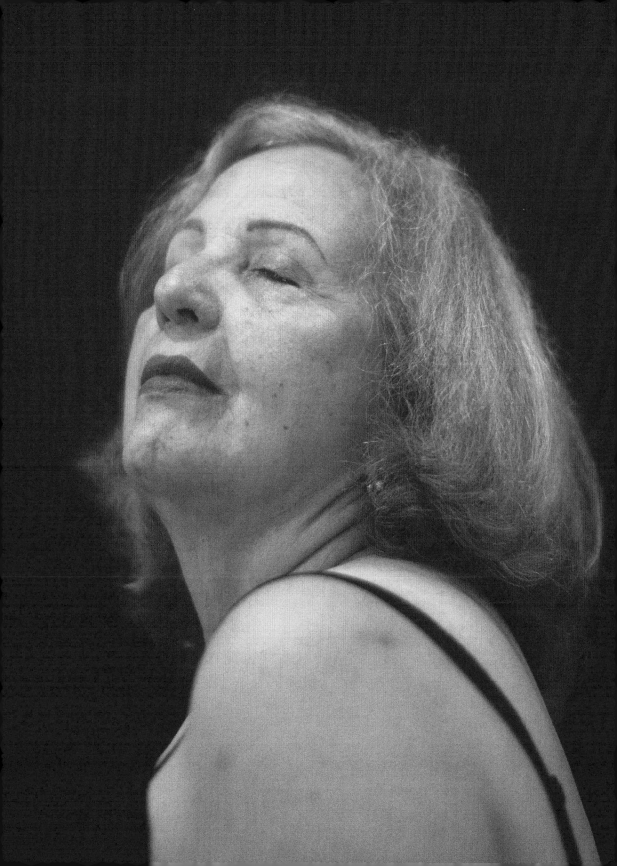

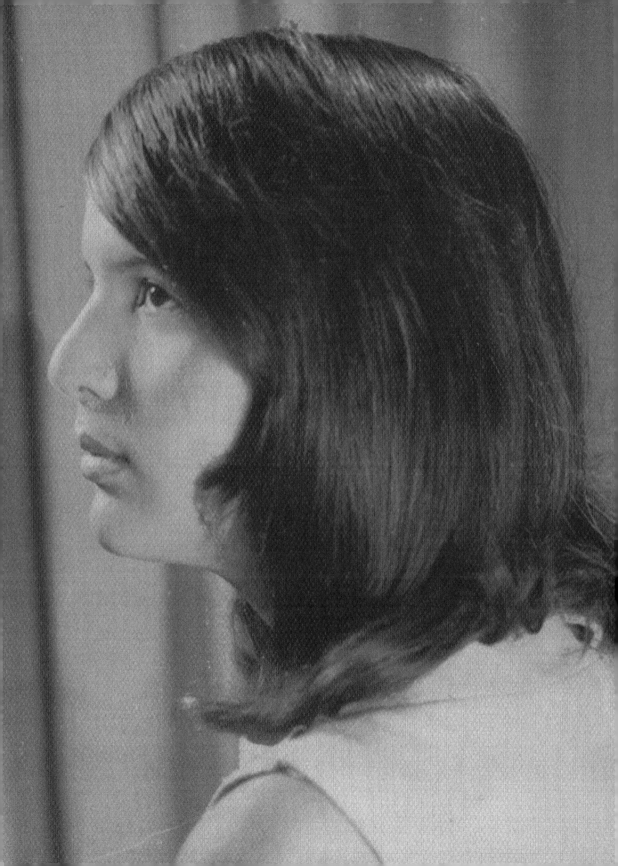

DUFFEL BAG

THE FIRE STARTED in the kitchen. It was close to midnight and the white fluorescent ceiling light started flickering, making split-second images in the dark. Still lifes of the ivory plates and bowls on the floating shelves, of the two plantains ripened black in the woven basket on the countertop, of the slim cart filled with all my cooking condiments and spices. Then the loud pop of a firecracker behind my kitchen sink as the water-heater cable ignited into orange sparks that filled the kitchen with slow-moving clouds of smoke. After eight apartments and three different countries, when I finally realized I wanted and deserved a stable home, freak things started to happen.

A month after spending all my savings to buy this apartment in Jersey City, a strong smell of sulfur started seeping from the electrical outlets, traveling through the baseboards from the rotted gas pipes in the hundred-year-old building. The odor became more apparent when you stepped out for fresh air and came back in, the apartment filled with the same smell of the inside of a stove when it's preheating. A few months later, the electrical panel in the kitchen began making a loud sizzling noise, the sound of eggs or vinegared onions hitting the hot oil in a pan. And almost a year after moving into this home, the fire. It had receded by the time the firefighters arrived, but they felt it still required spraying the extinguisher in the affected area and shutting off the power in the apartment. It was a cold December night, and after everyone left and the commotion died down, Amaru and I curled up in my bed in the dark, until my breathing slowly returned to its normal pace.

The next morning, the kitchen is cold and covered in a film of white dust, as if it snowed inside overnight. Black lines and indentations from

the firefighters' equipment mark the white walls, and debris litters the kitchen I recently renovated with my own hands. My fingers and the tip of my nose are ice, so I grab my thickest scarf and wrap it around my neck. Shivering in my cold apartment, I think of you and wonder if this would amuse you, if you'd think I deserve this for being such an ungrateful daughter. I'm a few months shy of turning forty, and it's been almost twenty years since I left you, my mother—only two days after graduating college—since I got far away from you en la isla, since I heard you say the words "I know you're never coming back" from across the living room as I stuffed a tall duffel bag on wheels with all my belongings. The kind of bag Dominicans traveled with in the 1990s and early 2000s, which looked like a fat centipede, filled to the brim, a colorful ribbon always tied to the handle to identify it in the baggage carousel.

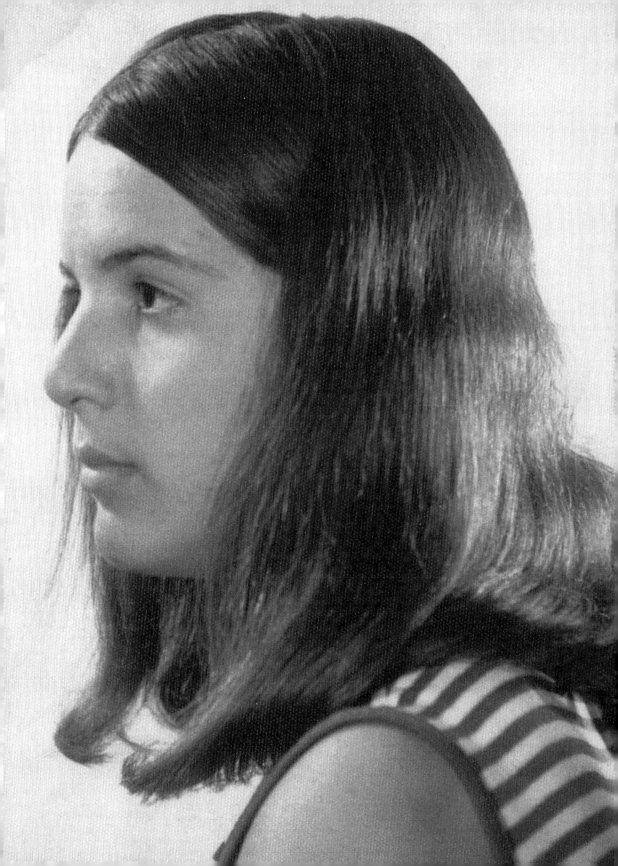

CAMPAIGNING

IT WAS THE SPRING OF 1994, I was eleven, and you took me campaigning for Joaquín Balaguer in our hometown of Santiago. Our golden Toyota Camry that made its way by boat through the Caribbean Sea and into our driveway now glistened under the sun as it moved through a sea of fluttering crimson flags, the color of the Partido Reformista Social Cristiano. The adrenaline rushed through my chest and down my skinny tanned legs as I squirmed out of the car through the open sunroof to get a better glimpse of people chanting "Balaguer, ese é! Balaguer, ese é! Balaguer, ese é!" I joined their improvised song, fists in the air with each mention of his name, until I became hoarse and lightheaded. You seemed proud.

Balaguer, who ruled the Dominican Republic on and off for thirty years, is remembered as a milder successor of Trujillo's bloody dictatorship. But this, of course, depends on who you ask. Papi disappeared in January 1988 while hiking the Pico Duarte. By then, Balaguer's government had already perfected its experiment of How to Disappear a Body, out of which Papi was another successful outcome.

The more I learned about our country, the more I realized that my anger at his disappearance was not shared by many people en la isla, especially not by the poor living in the countryside or the marginalized towns on the periphery of the larger cities. El pueblo remembers Balaguer fondly, their last imprinted memory of him being the small bags filled with a ten-pound sack of rice, salchichón, red apples, and fat grapes he delivered religiously every Christmas as a way to secure their votes, to guarantee any silence that was required. The lines to pick up these bags in Balaguer's home during Nochebuena extended

for several blocks, the police using their wooden clubs often to calm the crowd growing desperate under the scorching sun. In time, his Christmas bags and the ubiquitous free apartments for his supporters became more effective than the butt of the gun. When Balaguer died, it took twelve hours to transport the body from his home to the cemetery as a sea of grief-stricken Dominicans crowded the streets for a chance to see him. El pueblo was given twelve hours to say goodbye to Balaguer, but we, as a family, were not given a single second to say goodbye to Papi.

●

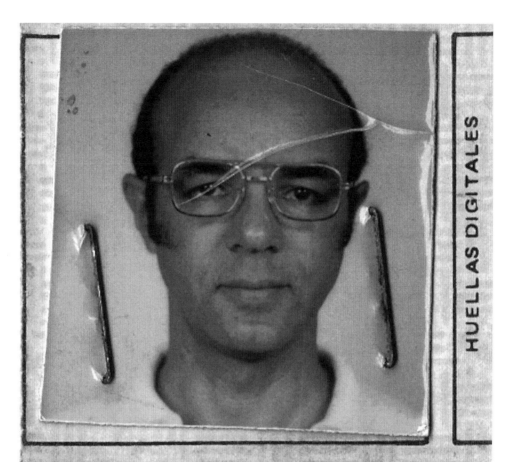

MORILLO GRULLON

t term until 1996, when he
…sidential duties. I watched
…ick glasses magnifying his
…g for him when you began
…ial in Balaguer's govern-
…ose organizing campaign
…etual repository of boxes
…ese boxes came in, Papi's
…e thousands of photos he
…lm trees in Portillo, the
…ped Papi and my broth-
…er in the warm, briny
…in the sea.

They used on Papi the same method they used to disappear the jour-
nalist Narciso González "Narcisazo" when he wrote his infamous article
"10 pruebas que demuestran que Balaguer es lo más perverso que ha sur-
gido en América."

You knew this when our family went on TV to denounce Papi's dis-
appearance, my aunt having to take over the conversation because you
were too upset to talk. In the video stills I pulled from the VHS tape we
kept of this TV appearance, you are wearing a yellow dress and five-
year-old me is wearing a pink one starched stiff with Niagara.

You knew this when you started dating H—a close ally to Balaguer—
and replacing all of Papi's photos with his in our home. You knew this
when you took me campaigning for the government that killed my
father.

WHEN PAPI "DISAPPEARED," my paternal grandfather paid Balaguer a visit to the presidential palace. He was allowed in only because as young boys, they had gone to school together in the city of Navarrete, the memories of those days softening the president into hearing Abuelo out.

"Señor Presidente, I came to ask for my son's body. Please, I promise not to retaliate. I just want to see him and say goodbye." I imagine their eyes watering as they spoke, their glasses a temporal wall concealing their distrust of each other. I picture them as boys, bright beyond the confines of their island, eating mangos on the side of the road, the trails of juice drying on their arms as they watch the cars speed by on the big road that leads to the sea in Puerto Plata. Two boys who would end up on opposite sides of their island's history.

That day, Abuelo walked out of the palace without answers but with a promise of a thorough investigation into the disappearance, a promise both men knew was a lie.

●

GROWING UP WITHOUT pictures of Papi fast-tracked my forgetting. You gave away all the slides of photos he took—mostly documenting our family's celebrations and his trips out in nature—to el limpiabotas, the young boy who came to shine our leather shoes once a month in front of our home in Santiago. On the sidewalk, single file, our school shoes and several pairs of your pointed-toe pumps, next to a cardboard box filled with physical evidence of Papi's sensibility. It eluded me why you felt that his photos outside our home, in the trash or in the hands of strangers, seemed more harmless than tucked away in a closet. Meanwhile, inside our home, large portraits of you hung on the walls, akin to those grandiose photos of communist leaders. The same size of the oil paintings of himself Trujillo forced el pueblo to buy and hang in their homes, captioned at the bottom in white letters: *En esta casa, Trujillo es el jefe.*

The absence of Papi's image as I grew up made the five years we spent together vanish into a single memory: him watching TV late at night on the plaid reclining chair in his bedroom. The inky hues of this recollection show me sitting on his lap, holding a pink-and-white plastic toy iron, trying to plug the small suction cup at the end of the curly cord into the flat part of his bald head.

As a child, I explained his disappearance to people with a rehearsed mantra: Papi es el ingeniero que se perdió en el Pico Duarte. I also memorized his achievements, collected from my relatives whom I pestered with my relentless questions. For example, I learned that he was a brilliant engineer who helped build the first cable cars in the Dominican Republic that traveled above the lush treetops in the coastal city of Puerto Plata. These were the facts I knew to be true, until the seventh grade when a boy in my social studies class asked out loud if my father was the man killed by Balaguer's government in the Pico Duarte, setting off the first bout of anger I would direct toward you for concealing the truth from me.

●

ABUELO SPENT ALL his adult life until his death in San José de las Matas, a small verdant city southwest of Santiago, where he was the town's only doctor. When he studied medicine in la UASD in 1930, only a handful of Dominicans had graduated college on the island. The only medical textbooks available en la isla were written in French, meaning Abuelo had to learn a whole new language before he could study medicine. This persistence in obtaining an education against the odds was something he instilled in and also admired in Papi, an engineer, a college teacher, and his only son.

If you visit San José de las Matas today, you can find a bust of Abuelo in one of the city's plazas, his face immortalized in white plaster with his name engraved below it: Dr. Rafael Morillo Burgos. Everyone remembers him for being the doctor who never took a penny from any of his patients. His medical practice was entirely pro bono, and the bust sits as a testament to the town's gratitude. But the smaller, seemingly insignificant things Abuelo is remembered for are the ones I hold most tender. One of them was the projectile force and quickness of his injections, followed by the swift swipe of a cotton ball doused in alcohol. One second and no warning. Old school. Another was his disheveled appearance and the perpetually open zipper on his pants, probably due to the garments being ancient—Abuelo vehemently refused to spend money on things he considered frivolous. When his patients pointed out that his fly was open, he would pretend to be mad and reprimand them for looking at his crotch, chuckling to himself as they apologized for the intrusion.

But the one thing I hold closest, the one aspect that is evidenced in my body, is Abuelo's dark skin—which I inherited only mildly due to your whiteness. The cinnamon of his skin was given to us by his mother, Teolinda, who was Haitian. Between your teeth, you mentioned her to me only once, almost inaudibly, like a shush. Yet, I want you to know

that my great-grandmother is permanently lodged in the single curl at the nape of my neck, in the concave space behind my ears. You never informed me of my darkness unless it was a reprimand. "Saliste morena a los Morillo," you would say, not milky white like the Echavarrías from your side.

As soon as I turned two and my hair began growing into tighter curls, you started diligently swiping these traces of blackness out of me. My short brown curls in that photograph on my second birthday were straightened with bottles of coconut oil you got from the countryside and the scorching heat of the blow-dryer. In the surviving pictures of my childhood, I sport buzz cuts until the age of five, your answer for getting rid of el pelo malo to make room for el pelo bueno. In one of these photographs, a studio portrait of me, I'm wearing a blue linen dress you made after studying royal children in magazines from Spain. My hair is shiny with oil and heated into a perfect bowl cut, the crown you concocted for me. The girl in this photograph, your vision of beauty.

Later on, when I turned fifteen, you took me to the salón and gifted me your same peroxide-blonde highlights as a birthday present and arranged a studio portrait session at the mall in Santo Domingo. I had asked for a party for mis quince, but you gave me the portrait session with you instead. In the photos, I am wearing a champagne-colored dress that you chose for me. You asked the hairstylist to fashion my hair after yours, a stiff updo parted to the side and sticky with hairspray. The photographer gave me a bouquet of white plastic flowers to hold while you held me against the marbled blue studio background. We, an artifice from head to toe.

I know you did this lovingly, that making me look like you was your way of protecting me. How, en la isla, the vision of progress and sense of worth parents give to their children is often linked to identifying our

white bloodlines, looking for nuestros ancestros españoles in our last names, in our skin, in the shape of our nose. But I'd like to remind you, lovingly, that beyond the fading sensations of my bleached and burned scalp, I am still Teolinda's great-granddaughter. Still black behind my ears. Still negra.

●

ABUELO HAD BEEN watering a bed of pink flowers in front of his home in San José de las Matas when a stranger approached him. It had been five years since his meeting with Balaguer, since Papi's disappearance. Abuelo folded the green hose over itself to stop the water from leaking, giving the man his undivided attention. A retired military man, he had come to speak to Abuelo about what happened to Papi that January day in 1988 in the Pico Duarte. Cancer had taken over the man's health, but what he kept quiet seemed to be killing him faster.

In the version we've known our whole lives of Papi's last moments, he was hiking to the summit of the mountain with my brothers and a group of his friends when he felt lightheaded and decided to stay behind and rest for a moment. That was the last time anyone in my family ever saw him. But in the version the man told Abuelo, Papi woke up from his nap disoriented and took another route to the summit. On this detour, he encountered something he shouldn't have seen, something being performed by military men in the mountains. His Minolta camera strapped across his chest—landscape photography was a favorite pastime of his—gave the wrongful impression that he was there to gather evidence. They hit him with the butt of a gun, only once at first, then repeatedly to get him to confess to things he had no knowledge of. They transported him, bruised and unconscious, to the military base of San Isidro, and when he died from his injuries a few days later, they tucked

his body in a barrel and threw it into the sea. The man, who had been stationed at San Isidro at the time, had seen everything firsthand except what happened in the mountains, information the rest of the brigade kept from him. From inside Abuelo's house, our family watched the two men speak their soundless words from the distance, from one dying man to another.

⬤

A FEW DAYS BEFORE Abuelo died, he called me to his bedside and handed me a clear bag filled with coins. The air trapped under its tight knot shaped the bag like a balloon, like the temporary homes fish inhabit on their way out of the pet store. His throat cancer impeded him from speaking clearly, so I put my ear over his warm breath and heard him whisper, "Erika, I dreamt you were in danger and needed to make a phone call but didn't have any coins to use the telephone. I want to give you these coins, to make sure you'll always be able to get help." The room was warm, and the small white table fan carried the cinnamon of his skin to my nostrils. He quickly fell asleep. His hands, dark and fragile over mine. The bag of coins, now so heavy on my lap.

⬤

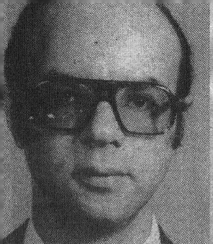

Descartan ingenier...

Por LEO REYES

El señor Eugenio Cabral proclamó que la Defensa Civil cumplió fielmente con su papel de buscar en la cordillera al desaparecido ingeniero Rafael Morillo Grullón con lo que se cierra casi toda posibilidad de que el profesional esté vivo o muerto entre los trillos cordilleranos.

No obstante admitir que la Defensa Civil no tiene ya nada que buscar en las estribaciones montañosas de la Cordillera Central, Cabral aseguró que si el presidente Joaquín Balaguer instruye continuar la búsqueda "lo ha...

Morillo Grullón

r el menor
saparecido o
rededor de un

r de la Defe
ue es práct.
el ingeniero ...

igue búsqueda ingeniero Morillo

BIENVENIDA SARDA

SANTIAGO. — Todo estaba estrictamente ...lado para la expedición que el pasado 2 de los ...ientes emprendió el ingeniero Rafael —Eddy— ...llo junto a sus tres hijos y dos compañeros de ...sión, hacia el Pico Duarte.

...o misma le ayudé a preparar la comida que se ...ron", recuerda doña Clara de Morilla, madre del ...esional de 42 años desaparecido la víspera del Día ...eyes en las cercanías de Mata Grande, San José ...s Matas, cuando había emprendido el viaje de ...eso.

...er, en medio de una fría y lluviosa mañana

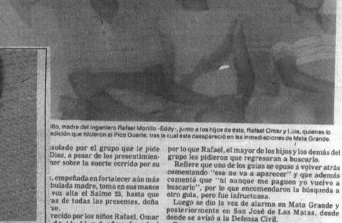

...illo, madre del ingeniero Rafael Morillo -Eddy-, junto a los hijos de éste, Rafael Omar y Luis, quienes lo ... edición que hicieron al Pico Duarte, tras la cual éste desapareció en las inmediaciones de Mata Grande.

...solado por el grupo que le pide ...Dios, a pesar de los presentimien- ...ner sobre la suerte corrida por su

..., empeñada en fortalecer aún más ...bulada madre, toma en sus manos ...voz en alta el Salmo 23, hasta que ...as de todas las presentes, doña ...se.

...recido por los niños Rafael, Omar ...de 14, 11 y 9 años de edad ...u padre se perdió la mañana del ...tuvo a descansar un momento, ...e prosiguieran camino a uno de los ...ten en Mata Grande para los ...e él esperaría el paso de los dos ...pañaban y que venían detrás.

...edó Morillo, hasta el lugar donde ...los ingenieros Leonel Salcé, y Rafael Despradel, junto al estudiante Freddy Martín Espino y los hermanos Morillo les esperarían, hay unos 35 kilómetros de distancia, según el relato de los familiares.

Sin embargo, ni los guías, que pasaron minutos después por el lugar, ni otros excursionistas que merodeaban por la zona, declararon haberlo visto al pasar por allí.

"Cuando los muchachos vieron que los guía llegaron con los mulos y que Eddy no estaba con ellos, le preguntaron ¿y papá?", relata doña Clara.

Agrega que los guías respondieron no haberlo visto.

por lo que Rafael, el mayor de los hijos y los demás del grupo les pidieron que regresaran a buscarlo.

Refiere que uno de los guías se opuso a volver atrás comentando "ese no va a aparecer" y que además comentó que "ni aunque me paguen yo vuelvo a buscarlo", por lo que encomendaron la búsqueda a otro guía, pero fue infructuosa.

Luego se dio la voz de alarma en Mata Grande y posteriormente en San José de Las Matas, desde donde se avisó a la Defensa Civil.

Pero ayer sábado, cerca del mediodía, aún se carecía de noticias respecto a la búsqueda en la que participan además, efectivos militares, voluntarios y familiares del ingeniero Morillo.

Mientras la madre de Morillo se mantiene cerca del teléfono, los niño pasan la mayor parte del tiempo en sus habitaciones, junto a su pequeña hermana de 4 años de edad.

La esposa, señora Lourdes Echavarria de Morillo estaba supuesta a regresar al país ayer desde Estados Unidos, donde se encontraba al momento de la desaparición de su esposo, quien dirige la firma de construcción, "Indian Asociados".

Al momento de su desaparición, Morillo portaba dos cantimplora...
chocolate, una lata ...
galletitas de soda, ...
consumido desde ...
incrementa aún m...
amigos.

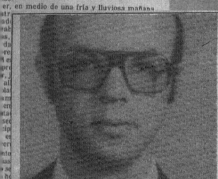

Rafael Morillo Grullón

Primera fila

Un mes después de haber desaparecido en las inmediaciones
...del pico Duarte, la gente pregunta con inquietud qué ha sido del
...unidad de estar bien, pero que si pasa del
...brigadas de hombres a seguir buscándolo,
...se empezaría a sufrir", señala la vecina,
...medio de la conversación, doña Clara Martínez

Ing

Por NELSON ...

La versión
hace un mes, ...

Creen in

Por PERFECTO MARTINEZ

SANTIAGO. — El ingeniero Rafa
Morillo desaparecido en el pico Duar
desde hace 21 días, estaría en casa
familiares en San José de las Mata
podría presentarse entre hoy y mañan...

Mal tiempo domina

Por MANUEL TORRES

El director de la Defensa Civil, Eugenio Cabral, afirmó que la búsqueda del ingeniero Rafael —Eddy— Morillo se dificultó ayer debido al mal tiempo en la Cordillera Central.

Cabral dijo que hoy en la mañana se reiniciará la búsqueda, con cinco brigadas de la Defensa Civil y un helicóptero de la Fuerza Aérea Dominicana (FAD).

"El mal tiempo reinante", manifestó Cabral, "imperante en todo el valle de Bao, dificulta la búsqueda del ingeniero Morillo".

El ingeniero, d...
inmediaciones de ...
Matas, a unos 40 ki...

Cabral manifest...
personal médico ...
emergencia.

Se dio cuenta de ...
diabetes.

Cabral manifestó ...
la conducción de ...

Espera que el h...
mañana de la base ...

Cabral dijo que, ...
Bao, se necesitan p...

este en frontera

vivo a un mes de desaparecido "y si estuviera muerto, y su cadáver se lo hubieran comido los puercos cimarrones que hay en la zona, aunque fuera la ropa de él hubiéramos encontrado".

Aclaró que no es cierto que haya asegurado nadie que el ingeniero Morillo había aparecido sino que lo que comunicó a algunas personas fue la información que recibió de la radio de un avión privado mientras se dirigía en helicóptero al Pico Duarte a llevar provisiones.

"Dije en esa ocasión", manifestó

compañía del señor Santiago Fran Objío, su hijo, el doctor Rodríguez personas más.

Relató que un hijo de Morillo Gr a quien no identificó, y su prim doctor Morel, "nos dijeron que cierto que el ingeniero había aparec que su esposa se había comunicad él y que había partido a Santo Don a reunirse con él".

Sin embargo, dijo, "resultó que esto era mentira" y se preguntó habrá detrás de todo esto".

Sostuvo que lo único que ha hec

Civil es "buscar a al desaparecido, c scado a un hijo de mach se de su verdadero pap a relación con las Fue en este sentido fu y los servicios d

miliares del ingen emplazaron a las auto comuniquen el destin illón ante sospechas de aber sido apresado.

Rafael Morillo Grullón

Ingeniero Morillo

Organizaciones de reclaman de las autoridade el caso del ingeniero Ra Grullón, desaparecido mie de una excursión del pico

El Partido Comunista (PCD) de los Trabajador nos (PTD), la Unión Antiimperialista (UPA) y

iero pudo irse para Haití

a sobre la desaparición afael Morillo Grullón, es habría salido del país la frontera.

sa versión es investigada autoridades que han no contacto con similares Haití, pero no se tiene avía informes concretos, n se supo.

e cree que Morillo Gru viajó por Elías Piña a de habría sido conducido un campesino que ontró en las cercanías de Juan de la Maguana. luego se habría valido de

haberse desaparecido cuando pa excursión numerosa en el Pico Du

La versión de que Morillo Grullón ha circulado con cierta discreció autoridades, y por lo tanto apenas

Se ha investigado las razones que el ingeniero para abandonar e clandestina, dejando tras sí una est desconcierto para sus familiares.

Dice una versión que Morillo Gru inconvenientes con socios de una c se ha revelado en qué consistieron.

También se dice que tuvo problem dentro de lo normal en un matrim

Todo esto es, sin embargo, part oficiosas que se tienen sobre

Eddy Morillo

Los familiares del ingeniero Eddy Morillo han solicitado al presidente Joaquín Balaguer que designe una comisión que investigue y establezca el paradero de su pariente, desaparecido en los primeros días de enero último, al retornar de una excursión al pico Duarte.

El presidente Balaguer recibió a una hermana del ingeniero Morillo, y aún cuando no se conoce lo tratado en esa junta, se tiene entendido que la doctora Carmen Morillo de León expuso al jefe del Estado argumentos que no ha esgrimido en

eniero sale hoy o mañana

a, nadie está buscando a Morillo realmente él no está desapare o oculto en casa de familiares San José de las Matas", dijo la

gó que ni la Defensa Civil ni las Armadas buscan ya a Morillo

Inmediatamente se dio inicio a una afanosa búsqueda en la que participa ron voluntarios, militares y guías especializados.

En una oportunidad llegó a publicarse que el ingeniero había aparecido y que había sido trasladado a la base de San

WHAT PAPI SAW still remains a mystery. Eyes closed, I try to imagine what he saw in those mountains that cost him his life, but no images come to mind. Only a gaping black void. An empty space that now as an adult, I fill with everything I fear. With the light brown mole on my nose that I obsessively check to see if it's cancerous; with the thought of Amaru going to college and keeping in touch only seldomly like American kids do when they leave home; with the ceiling lights in my kitchen that, despite the extensive electrical work that has been performed, still keep flickering.

I make sense of his void by imagining him. The clothes he was wearing when he was last seen: blue jeans, walking sneakers, a red polo shirt. On his wrist, a Bulova watch with black leather straps, with his birth date engraved on the round golden caseback, a gift from Tía M in Nueva York. I imagine the shades of rust that metal collects when submerged in seawater. Concrete is heavy, but the round watch is light and levitates away from the skin, and what will later become tendrils of moss starts out as tiny bubbles filling the space between his skin and the levitating watch. A floating circle resting on smaller ones, the geometry of my pain.

I imagine the possibilities that can happen in the span of the two seconds it takes to hit someone with the butt of a gun and leave him unconscious. In the span of un golpe seco.

Two seconds. I replace the blow with the sound of Papi's sneeze, with a sprinkling of sugar over my grapefruit, his way of getting me to eat it.

Two seconds. Fat drops of tropical rain filling my inflatable plastic pool in our backyard, the clean slash of his machete cutting through coconut husk before turning it upside down to fill my glass, white speckles of coconut meat floating in the cloudy water.

Sound itself can be a form of violence, but silence can be the most violent of all. A void that continues to kill after death. I now think of my chanting for Balaguer during those days of campaigning as your strange legacy of silence, how the women in our family have been either silent or silenced. En la isla, a man's mouth still the main instrument to inform, to legitimize, to kill.

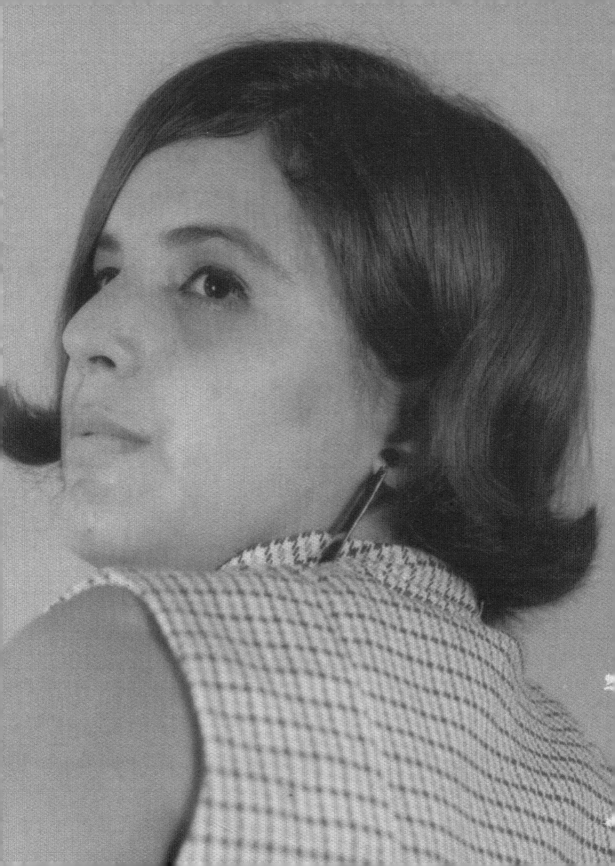

CARIBBEAN KITCHEN

THE ELECTRICIAN SAYS it will take two full days to rewire my apartment, to fix the maze of scorched cables and overloaded lines behind the ancient electrical panel in my kitchen. In the Uber on my way to Home Depot, the driver asks how my day is going. I practice the restraint I've learned in therapy of not oversharing my troubles with complete strangers and say, "It's going good." But as he does some small talk about his taxi rounds that day, I recognize a Caribbean accent and fish for an opening.

"Where are you from?" I ask.

"I'm from Haiti," he says, to which I reply, "I'm Dominican. We're neighbors!"

I immediately feel that my statement is loaded. I think of the complicated racial and political history of the island our two countries share and regret having said anything. He doesn't seem to mind and changes the subject to ask me what kind of home project I'm working on. I find my opening and start venting to him about all the problems my new yet ancient apartment is giving me. How I think I made a mistake when I bought it.

His dreads shake slightly as he nods. "I get it," he responds. He tells me he and his wife bought an old home in New Jersey a few months after September 11. They were young and had only enough for the down payment and closing costs, meaning they had to take on the renovations themselves. The entire floor was covered in beige carpet, and when they ripped it out, a beautiful hardwood floor lay underneath, though the upper layer was brittle, round moldy circles spotting it like a cow. It would take forever to sand it and renting a machine was expensive, so they bought a shabby used one. "The machine was so weak," he says, "it

wouldn't sand anything off. It needed some weight to make the sander disk go into the wood. So my wife stepped on it and it finally worked." He tells me how, for two weeks when they both got home from work, she would step on the machine as he sanded the floor in each room, talking about their day. She would threaten to abandon the project every couple of hours, but they stuck to it until the floors were sanded bare and each of the moldy patches had disappeared. They stained and glazed the wood a shade of chestnut brown, so shiny, he says, that on sunny days the trees outside reflected on it like small paintings through the windows. I hold the brown bag on my lap filled with expensive arc-fault breakers and brand-new smoke alarms and feel a renewed confidence about fixing the old wiring behind my walls, in mending the faulty connections endangering my home.

"Our hardwood floor looks very nice, but my favorite part is the kitchen," he mentions. "I painted the walls yellow and laid down terracotta tile on the floor. I love to cook, and it reminds me of the colors back home." From the back of the cab, naked trees lining both sides of the road, I enter his kitchen, orange and yellow, a perfect sunset, and I enter ours in our old home in Santiago. The huge windows above the sink that overlooked the tall coconut tree bent to the right, with the blade of Papi's machete still inserted in its trunk. The red swing he hung for me on the grapefruit tree. The guavas littering the floor that you'd later turn into casquitos de guayaba when H started visiting. You'd peel, cut, and deseed the guavas until you were left with a potful of hollowed halfmoons. You'd cook them for hours in a mixture of sugar, cloves, anise, and cinnamon sticks until they'd turn to red jewels in the heavy syrup. You are a wonderful cook.

The weekends H would come visit, I'd be woken up in my bedroom on the second floor by the smell of your cooking. Wafts of freshly baked

pan relleno, a fluffy white bread filled with stewed chicken shredded to strings, cubed ham, green olives, and raisins. Every mouthful sweet and savory, the bread tinted orange from the tomato paste you stewed the chicken in. By noon, the kitchen counter was lined with Pyrex dishes of pastelón de plátano maduro, moro de guandules, steak medallions in a mushroom sauce, and my favorite, arañitas, shredded yucca patties with eggplant, egg, and anise fried until golden, the yucca strings like spider legs sticking out of the fritter. No one was allowed to touch the food until H arrived. If he called last minute to say he'd make it by evening instead, we'd have to eat a sandwich and wait until dinner to eat the food. But I'd always find a way to steal a couple of arañitas without you noticing, run to the end of the backyard and eat them behind the wide trunk of our mango tree where I couldn't be seen. The same tree under which I would sit four years later, hot tears down my cheeks, as a swarm of strangers came to look at our house when you put it up for sale without informing us, to follow H to la capital.

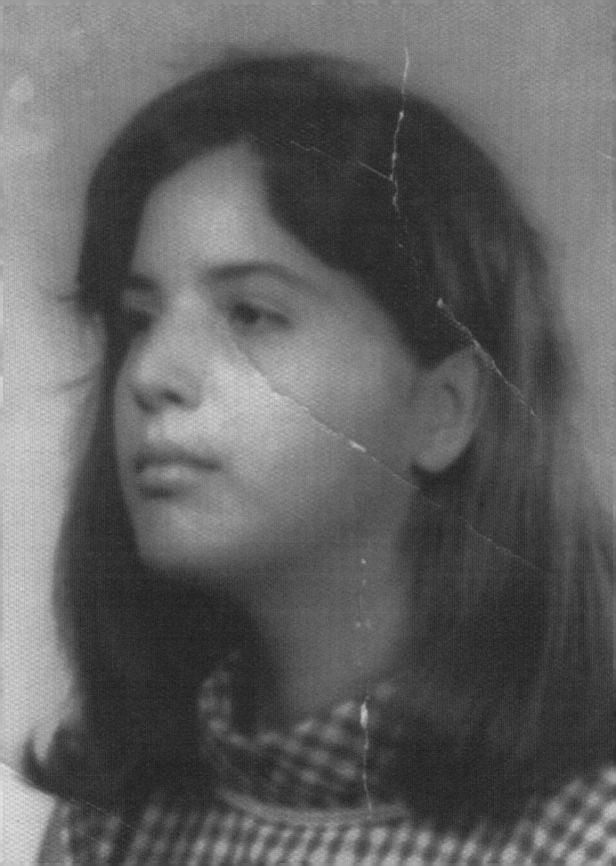

PIGS

THINGS GOT SERIOUS between you and H. That meant you needed to orchestrate care for us over the weekends so you could travel the two hours southeast to la capital to see him. My three brothers were teenagers and knew their way around the house and our neighborhood, where they had friends their age in every other house within a five-block radius. But I, at eight, required the arrangement of babysitting. You would leave me with anyone who would take me.

On this particular weekend, you sent me to Gurabo with Marta, a young woman who worked at your seamstress studio. These trips to strangers' homes always excited me. From the moment I set foot out of our house, there was a closeness, a kind of camaraderie between me and the stranger in charge of me, that soothed the lack of touch I received from you. Marta held my small hand as we walked the asphalted streets to the main avenue to take a concho to Gurabo. Quaint family homes painted in soft pastel colors lined both sides of the streets in our middle-class neighborhood of La Rinconada, with only bushes and lush trees in the front, before home fences became commonplace in the late '90s. We squeezed ourselves inside the concho until four people were crammed in the back. The small car reeked of gasoline and made spurting sounds as the driver stepped on the gas. I was squished tightly between Marta and another passenger, my arms warmed by their bodies inflating up and down with their breathing. A wonderful, accidental cradling.

When we made it to Gurabo, a dusty dirt road stretched before us with fields of wild grass on both sides. Marta's younger sister, Solanyi—who was my age—came running toward us barefoot, strands of brown curls glued to her sweaty forehead. She seemed undisturbed by the gravel

underfoot. I wanted to take off my sandals and be barefoot too, but Marta insisted I keep them on. The modest wooden house was unpainted, the shade of tree bark after the rain. The three narrow bedrooms led to a small living room with two rocking chairs and our dinner of boiled guineítos, stewed onions, and crispy fried eggs on the dining table. Dusk turned the pale blue of early night as Marta, her family, and I ate dinner. Marta's mother asked her if I liked the food, Marta a sudden translator between her family and my privilege.

Marta and I slept in her parents' bedroom that night, the biggest one in the house. The house had no electricity, and our room was lit only by a gas lamp on the night table, the white mosquitero glinting next to it like a billowing cloud of smoke over the bed. "Solanyi wants to play with you tomorrow," Marta said as we lay on our backs in the bed. It felt nice to go to sleep smiling.

As soon as the roosters started crowing and I felt Marta's body move inside her white nightgown, I said, "¡Ya estoy despierta!" I couldn't put on my shorts and T-shirt fast enough when Solanyi knocked on the door so we could go out to play. The expanse of land behind the house had tall grasses as far as the eye could see, interrupted only by small wooden constructions in the landscape. The closest was the pigpen, my first time seeing one up close. The smell of shit and rotten food stung my nostrils. The pigs looked so different than the ones I'd seen in my picture books. Not bright pink, but the pale pink of new skin when you peel off a sun-burned layer in the summer. Not smooth, but prickly with coarse white hair drenched in mud. Their food lay beside them, a goop of scraps with plantain peels and citrus piths, floating in a hollow truck tire sliced in half like a bagel. I realized I had to pee and told Solanyi. She took my hand, her palm rougher to the touch than mine, and hurried me to the latrine, another first.

She opened the corrugated zinc door and showed me how to prop myself up on the square wooden seat, making sure not to fully sit to avoid falling into the hole. "I'll hold the door so it's not so dark inside, and I'll make sure no one is looking," she assured me. I took my shorts and white cotton panties down to my ankles, held myself above the hole like gymnasts do on the balance beam, and heard my pee fall to the bottom in small thuds, not a trickle like at home. The smell that came up was worse than the pigpen. Vinegar and boiled tripe. I pulled my panties and shorts back up quickly without patting myself dry.

We spend the morning searching for small rocks among the grasses and seeing who can throw them the farthest, inching away from the house and toward another dirt road. "Muchachitas, muchachitas, vengan acá," we hear above us, the soft voice of a man looking at us as we're crouching down. We stand up to see him and he starts asking us questions. What are we doing there. Where are our parents. Did we know we are so pretty. He shifts from the third to the second person, lifting my face by my chin, his syllables slower and softer, "Y tú, ¿cómo tú te llama?" I have yet to say my name when his other hand is already inside my shorts, then inside my panties. His hand is rougher than Solanyi's. She and I become extensions of the stones in our hands as he keeps touching me and asking me questions. "¿Tú sabe' que tú ere' muy linda? ¿Tú sabe' que tú tiene' el toto muy grande?" I'm confused and don't know if I should say thank you. I feel like peeing again. Marta's voice calling us from the house makes my vision come back into focus, makes the ringing in my ears recede. She's tiny across the grassy field; I, frozen in place. We're the small green plastic soldiers my brothers have in a bin in their bedroom at home.

That night in bed, Marta and I stare at the white mosquitero above us, the night a dark blue through the open window. She's still quiet,

even after Solanyi and I apologized for wandering off and promised we wouldn't do it again. I turn to my side to face Marta and see her frozen on her back, her hands one on top of the other on her white gown. She's awake, her eyes wide open, but she doesn't talk to me, just like you when you allow me to sleep in bed with you. "Promise me you won't tell your mom about what happened today. She'll fire me," she says, still not looking at me. "My family depends on me, do you understand? If I get fired, we won't have money for food." I move my body close to the ice, place my small hand on top of its frigid surface. I am naked all of a sudden. "I promise," I whisper, my whole body covered in goosebumps.

The next morning, as we say goodbye and start walking down the dirt road back to the main avenue, Solanyi begs Marta not to leave so early, to stay home for lunch, but we walk fast, Marta pulling on my hand slightly. Knowing I have leverage, I let go of Marta's hand and stop walking. I look at her in silence, slowly take off my Xuxa jelly sandals, and walk the rest of the way barefoot, holding Solanyi's hand. The jagged stones dig into the soft soles of my feet, each step a jab in my jaw, every stride a bunch of sharp needles shooting up my legs. My first time walking on gravel.

●

H TOOK ME TO SCHOOL every morning while you slept. We had moved to la capital only a few weeks back and I was about to start eighth grade. My small, puffy breasts had begun to poke through the fabric of my clothes that summer, and I already understood what it meant to be aroused, as I discovered a couple of years back in Santiago when I came across the Playboy Channel after midnight while at home unsupervised.

At the end of my first week at the new school, I was roused from my sleep by H's hands thrusting inside my panties. The sensation reminded me of the pleasurable release of peeing in my dreams when I was little, only to find I never left the mattress. "¡Ya estoy despierta!" I said out loud when I saw his burly body and white head of hair hovering over me. His chest, covered in the same prickly white hair as the pigs in Marta's backyard. His hands, my welcome to his home, pounding to bits my hopes of having a father again.

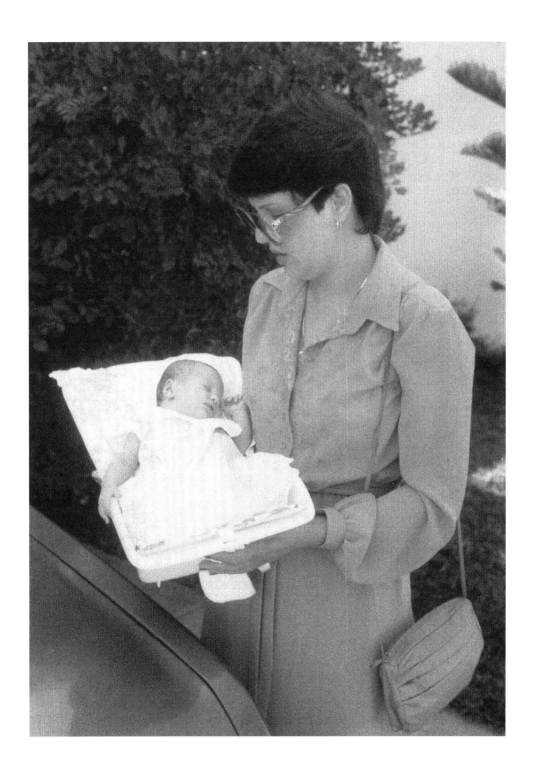

TWO

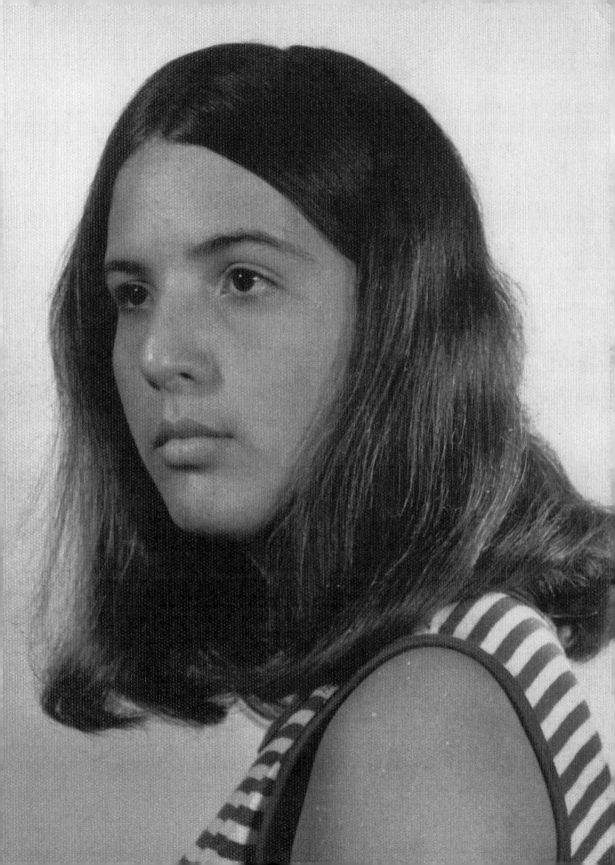

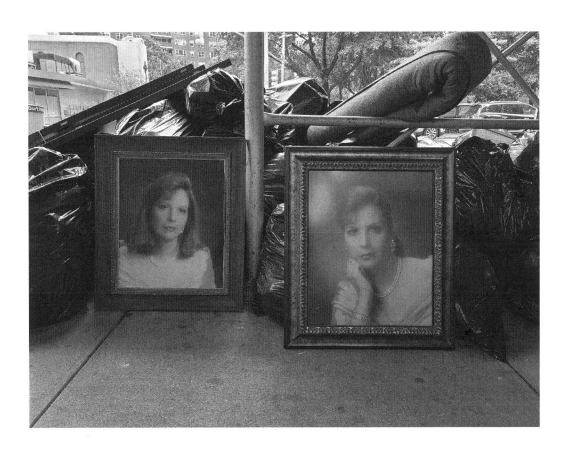

DISCARDED

FOR YEARS, YOU SENT ME by mail all the pictures you still owned. Sometimes they were pictures of my nephews and nieces, your grandchildren, that had been given to you as keepsakes. Occasionally there would be a photo or two of me. The last ones I received came in the midst of the pandemic, as I made the painful decision to leave Nueva York after fifteen years of living there. It was summer, and I propped the two portraits you sent against the large trash bags lining the sidewalk on the corner of Ninth Avenue and Twenty-Fourth Street. The air carried the acrid smell of rotten vegetables and overripe fruit, and looking at your face resting on the dirty pavement, I felt guilty for not taking your photos home with me. I could barely pick up the heavy box with the three-foot-tall framed portraits you sent to my old apartment, let alone drag it on the PATH back to Jersey City. I had to decide what to do with you, and in a split second, I opted to put you in the trash. I tore the box with my house keys and undressed you out of the plastic wrapping. Holding your gaze through the cloudy glass on the frames, it unsettled me to see how much I resemble you, even in my rejection.

●

IN OUR FAMILY, grieving entails a systematic discarding and hoarding of images. You grieved by giving away Papi's belongings, his Minolta camera in the black leather case that we kept in the attic, his thousands of Kodachrome and Ektachrome slides and the gray plastic wheels that housed them, which I now browse on eBay when I have insomnia. I grieved by stealing every photograph I found in our house and studying it in detail until a copy of the image was stored in my memory, away from your reach.

I started by amassing some black-and-white studio portraits of you when you were young and analyzing you in these pictures. No single image depicts you clearly, only the accumulation of them seen as a whole. An underlying grin that never breaks into laughter, your ability to morph into someone else entirely from one minute to the next, where I become not your daughter but a stranger. Your straight black hair and fair complexion, the traces of foreign white blood we Dominicans love to claim and that, in me, are largely absent. Putting my nose to the brittle photo paper, you smelled of a vast library. Of the *Wuthering Heights* copy I found in the street in Santo Domingo, before I could speak any English, its pages fattened by the rain into a wavy accordion; of the old book of Shakespeare's plays a friend gave me, which sits unread on my bookshelf at home; of the children's books that one by one you started to remove from our home library in Santiago until the wooden shelves were empty and housed only the fancy glass vases you collected. You, a collection of tragedies I can't bring myself to read.

❋

MY FIRST GLIMPSE of this picture was one afternoon after school when I saw you passing it around to the women who worked at your seamstress studio. "This is me as a child," you announced, lifting your chin the way you do when you claim the center of the room. I have accepted that I am not privy to our family's photographs unless I steal them, often during visits to the homes of our relatives, who constantly reprimand me for my detours into their closets and musty basements. My small-scale photo theft currently amounts to a single medium ivory box filled with cheap glossy prints, a few slides shot by Papi, and some old black-and-white images bent into cylinders.

This one photograph, however, I did not have to steal. You sent it to me last summer, twenty years after you had it digitally restored and colored. In it, Abuela—your mother—is posing with her nine children, who appear to be organized in three distinct layers in the frame, a pyramid. You and my younger tíos and tías are clustered at the bottom right of the frame, the way I've seen newborn animals sleep in a mound to feed off each other's warmth, the same way you and your siblings would later be corralled out of Jarabacoa in the back of a truck when Abuela died. In the middle of the frame are my older tíos, including Tía B, who seems to be looking not at but through the camera, her head slightly tilted, as if this instant of image-making was not a reveal to others but a way to go into herself. In the upper part of the photograph, we see Abuela holding her youngest child, a baby boy. But I am fixated on what I cannot see in this photograph. Certain aspects of it tell me that Abuela was in a hurry on the day it was taken. Perhaps a photographer walked the streets of Jarabacoa offering to take photos of people to make a living, and she had only a few minutes to gather her children scattered at the skirt of the mountain, forgetting to clothe the naked baby in her arms. Her bare lips and pinned-back hair point to a photo taken later in the afternoon,

when the day's chores and Caribbean heat had already washed any traces of embellishment off her. Or maybe it was Abuelo who took the photograph, in which case it would make sense that she, defiantly, did not want to make an effort.

With the same resoluteness you used to have it restored two decades ago, you carved yourself out of this family picture. You extract yourself from every photograph where you appear with someone else, leaving behind a trail of isolated, rectangular shapes that now, on my living room floor, I arrange into landscapes where you become every building in the skyline. You erase and I reconstruct, our intimate dance. The delicate act of combing through a heap of ashes.

●

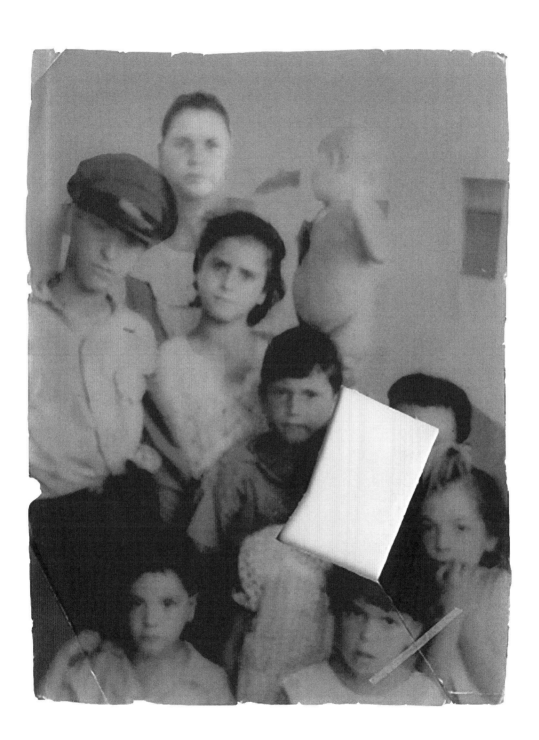

INSIDE THE CRINKLED MANILA ENVELOPE with this photo, you also sent a restored portrait of Abuela. She had been digitally whitened in this image, her already alabaster skin layered with a lighter exposure, the deep cracks that I imagine populated the original black-and-white print replaced with a painterly pastel-colored surface. Her lips are shaded a coppery brown, her jet-black hair just off hot curlers, her eyebrows painted with the carbonized tip of a lit-off match, and the front teeth, a pair of jewels lined with gold underneath her lips.

Her face is an amalgam of mutilated pixels, but down her neck, a shape I recognize in my own body. A curvature in her back leading to a slight indentation in each of her shoulders where the brassiere straps lie, denoting the big-breasted bodies of the women in our family. Indentations that become deeper with each child we bear and that make me self-conscious when my shoulders are naked. She was elegant, as evidenced by the balance of elements decorating her body. Painted lips but bare ears, a printed dress against a naked neck.

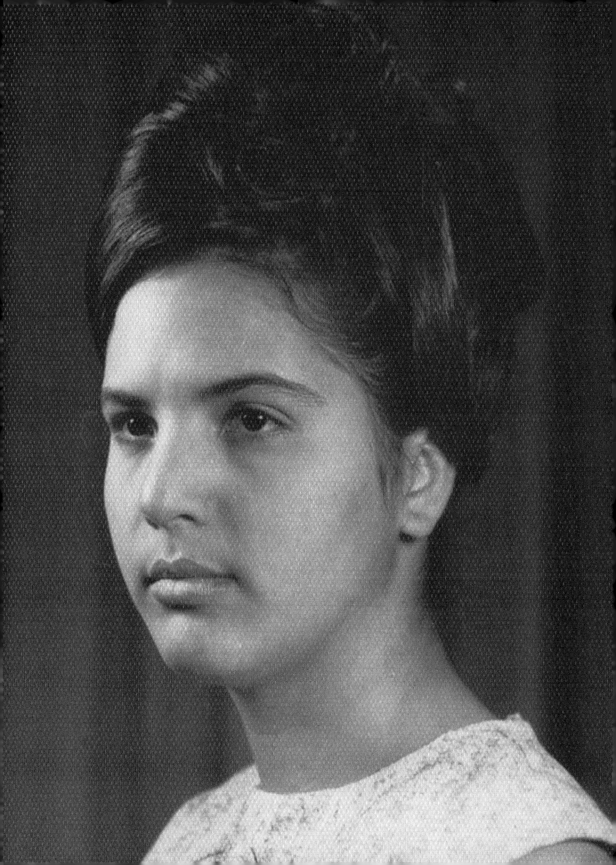

LA ISLA

ON THE COVER of the Lonely Planet guide to the Dominican Republic, there is a row of wooden beach houses painted in bright colors at the center of the image. A yellow door, a pink zinc roof, a coral verandah. The houses are canopied by palm trees so thick you can barely see the blue sky. At the bottom of the image, a single wave reaching its foamy peak. But what I fixated on was the small blue text on the left of the cover:

> Local Secrets
> Best planning advice
> 100% researched & updated

When you're struggling to find meaning in the absurd, anything can read like poetry.

In our paradisiac corner of the world, tucked between the Caribbean Sea and the wider Atlantic Ocean, a woman is killed every two days at the hands of their partner. En la isla, 1,228 kilometers of powdery white sand and turquoise water beaches circling women like a tight fist around their neck. In my motherland, 357 women were murdered in the last four years by their lovers. They lay in soiled suitcases in the matorrales; in large black trash bags on the side of the road; on the pavement, eight stories down from a hotel balcony; or in the case of Abuela, on her kitchen floor surrounded by you and your siblings.

●

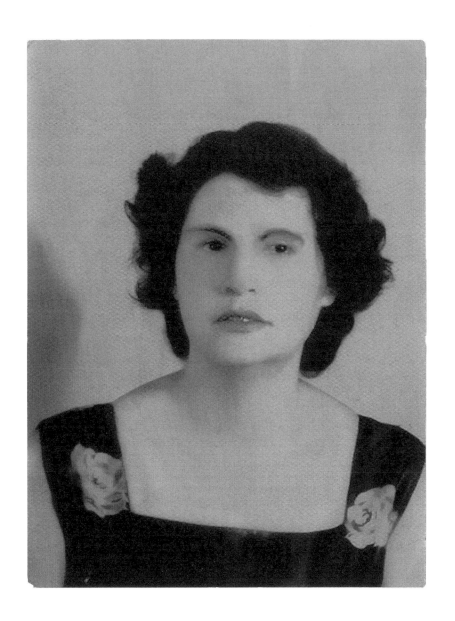

IT HAS TAKEN ME three days to write this half a page, to articulate in words the origin of your hardness.

I parse through this maelstrom of secrets and attempt to put together my own archive of our family, my personal guide to our motherland. I gather the information piecemeal, with every question I ask strangers. With each new visit to the island, my family history one hundred percent researched and updated, until someone else is willing to let me into a new secret. But never from your lips. From your lips only the palatable version: "Your grandparents died in a car accident in Jarabacoa." Another cover that says nothing about the place where I come from.

The real image behind your iciness: Abuelo and your brother's lifeless bodies on the outskirts of your childhood home. Abuelo, a man who killed your mother in their kitchen and, while your teenage brother chased him to take the gun, ended up killing him too before committing suicide. In your life and in mine, kitchens ablaze, "home" a treacherous place.

When they found the bodies on the dirt road that curled down the mountains to la Autopista Duarte, inside Abuelo's white shirt was a plane ticket to Nueva York, a journey his daughters would end up taking instead of him years later. Nueva York, the way out of an island where, after becoming orphans, his daughters were traded around like damaged cattle. Nueva York, the cold apartments your sisters arrived at on Vermilyea Avenue in Inwood and Hunts Point Avenue in the Bronx. Sticky linoleum floors, cupboards crawling with German roaches. A place where no one knew them and they could start fresh. Nueva York, the city where his granddaughter now writes her only image of him.

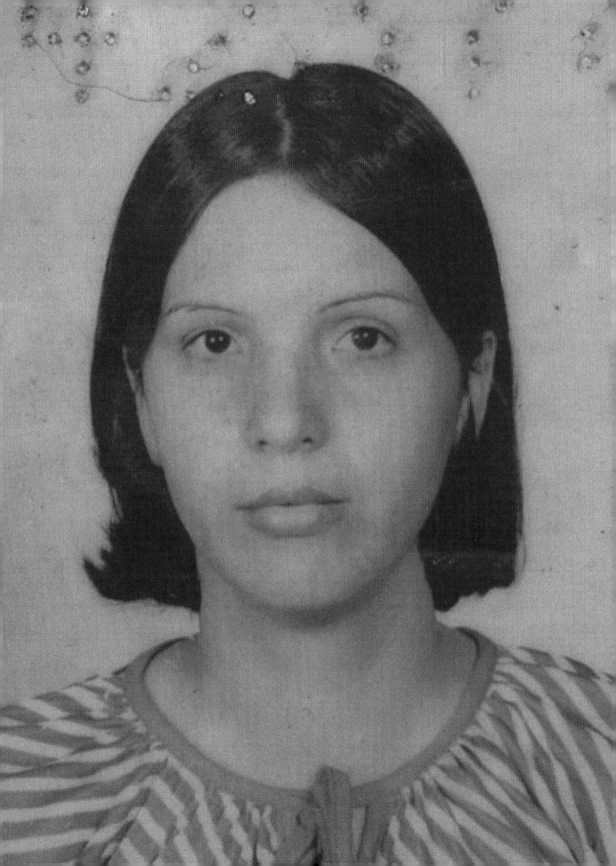

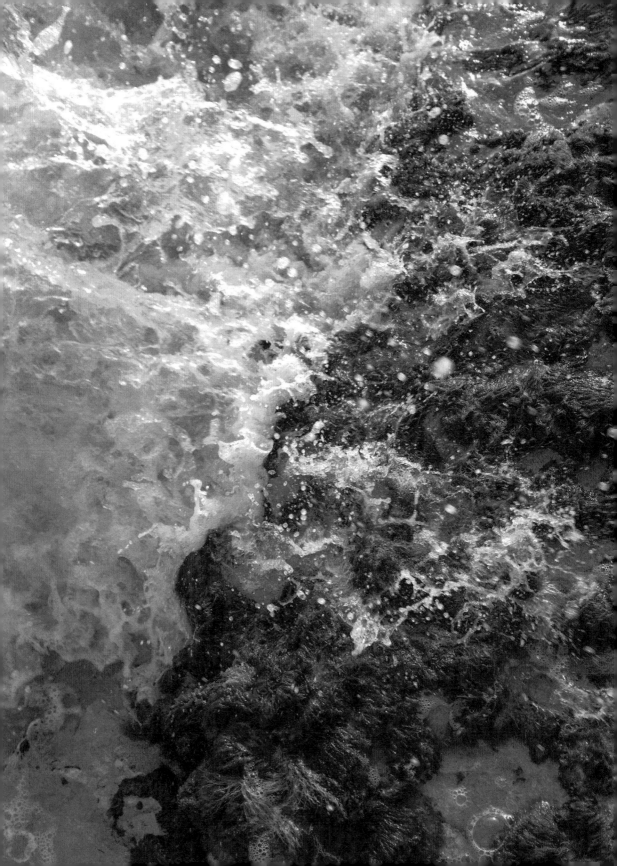

BEDS

"LA CASA SE ESTÁ QUEJANDO, it's trying to tell you something," Coni—my therapist—tells me when we discuss my fear of my home catching fire again. Earlier that day, the electrician replaced the electrical panel, put in all the fancy breakers that make intense electricity stop in its tracks, and checked the light bulbs and switches to ensure everything was tight in place. But when I go to microwave my cup of coffee that has grown cold, the breaker trips and the kitchen light starts dimming and brightening, flickering, and then returns to normal. I stand in the kitchen, waiting for the light pattern to repeat again, phone in hand to record it on video.

After Tía M assures me again that this is not dangerous, I hang up the phone. I bring my cat from the brown leather chair in the living room—his favorite spot—and place him on my bed, although it took months to forbid him from sleeping with me. The tiny black hairs he leaves in his wake on my white duvet make my asthma flare up, but tonight, I want him to curl into a ball behind my knees—his second-favorite spot. Amaru is already asleep, and I don't want to startle him by getting in his bed and hugging him, something I do when I'm really anxious.

In my bed, the dark room lit only by the blue light of my phone screen, I think of what Coni said and rewatch the video of the kitchen lights on my phone. I find the ebb and flow of the blinking light resembles the sound waves of an audio recording. Then I watch two middle-aged white men discussing possible causes of blinking lights on YouTube, and another electrician in Canada as he takes us from inside a home to a snow-covered driveway and explains that sometimes severe weather can corrode the electrical wiring outside. It's now 2 a.m., my eyes sting, and

I realize how much I hate my hypervigilance. I hate my need to ascribe symbolic meaning to situations that are just shitty. I hate feeling that I'm still a few doors away from you, in my bed en la isla.

●

I RUSHED TO THE BATHROOM on my tippy-toes so I wouldn't wake you. It was just a few steps from your bed to the en suite bathroom. The tip of my big toe touched the cold tile floor as I sat on the toilet; then a warm release. I was proud of myself for not having another accident, happy to be in your bed and not alone in mine in those days after Papi disappeared.

You come to the bathroom to give me a hug while I'm still sitting on the toilet, swaying me left to right in your arms. I hear you say something, but your words are fuzzy around their edges, a mound of letters made of cotton. Your voice pierces through the thick fog: "¡Te measte otra vez!"

I stand by the bed in my soiled pajamas, staring at you as you undress the mattress and start to insult me through clenched teeth. The fog returns. The white sheets are now a snowy mountain on the floor. I am staring at the mountain, which looks like the one in the VHS movie we have downstairs, where the young girl is sent to live with her grandfather in the Alps. In the movie, the girl finds a pile of hay in the attic and declares this is where she will sleep. Her grandfather helps her fatten the mound and drape a white sheet over it. Through a round window next to her new bed, she is able to see the range of mountains, a progression of greens and blues leading to snowy peaks. I wonder if hay soils and what the cold snow would feel like against my bare skin.

●

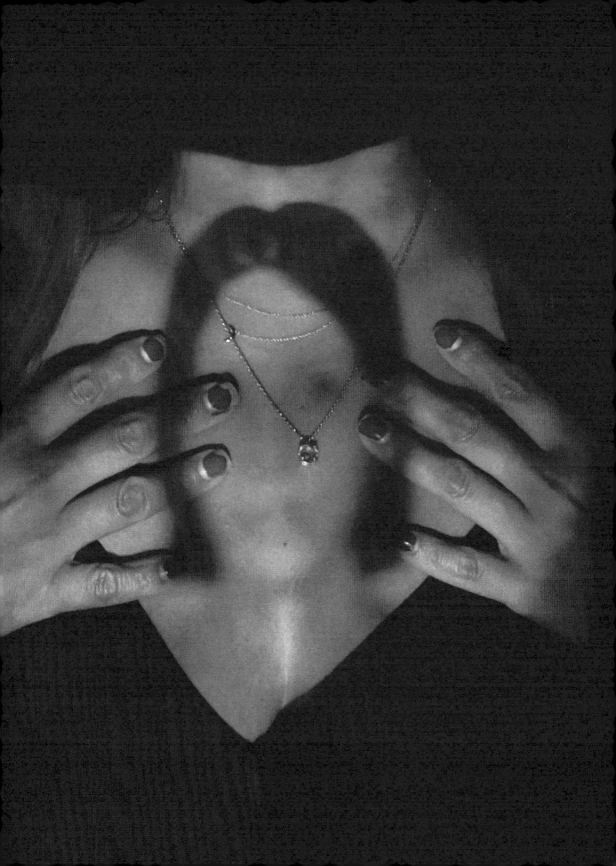

TÍO M TALKED TO ME about your childhood home the last time I visited him in La Vega. He said all you nine kids slept in a single long bedroom, a railroad-style room with the cots lined up in the center like tracks. Every year near Christmas, you and your siblings headed to the mountains to fetch Spanish moss off the tall trees, stuff it in rice sacks, and take it home to fill the mattress bags. Tío M mentioned that he slept the soundest that time of year, when the mattresses were plump and he could barely hear the cot rattling underneath you when one of his older brothers visited your bed at night. A sound he couldn't put together until he came of age, one that helped him understand why you disliked being touched and rarely hugged anyone.

He said no one has lived in the house since your parents died, and the two bullet holes are still visible in the wooden slabs of the kitchen, sixty years later. He offered to take me to the abandoned house in Jarabacoa, but I refused. I feel guilty whenever I meddle with your past, when I go too deep into your childhood, as I am constantly reminded by my family that this is not my story to tell. But when I look at my own childhood, I understand that by giving birth to me, you also gave me this tragedy to unspool, like a gift you carefully wrapped and placed on my lap.

•

MY CAT JUMPS on my lap and hogs the phone camera as we FaceTime, me from my apartment in Jersey City and you from your house in Miami, where you moved after becoming a widow again. After twenty-five years of marriage with H. My cat's black face and yellow eyes stare into yours through the rectangular screen. Your expression sours and you call him gato prieto, the ugliest thing you've ever seen. You suggest he go for a visit to your home in Miami, that you will make sure he never returns.

"What do you have against cats?" I ask, and with uncharacteristic generosity, you proceed to tell me a story.

You tell me that when you were a child, there was a cat in your home that used to scare you in the middle of the night. He'd startle you out of your sleep by playing with your long dark hair dangling from the cot to the wood-planked floor. Your heart would jolt at the touch of the cat in your sleep, making you instinctively cover your body with your hands over your pajamas. You dreaded the cat touching you in your sleep and his persistent visits to your bed while everyone else slept. You told Tía B, your eldest sister, about the cat and she offered to help. At fourteen, Tía B was already hardened by the tough labor she was asked to do around the house and the farm, which included helping kill the pigs when they were ready for slaughter. Was she thinking about the pigs when she looked through the camera in your family photograph?

You both plotted to get rid of the cat. She gave you a piece of thin rope, which you kept underneath your pillow and circled around the cat's neck when he reached for your hair that night. Tía B undressed her pillow from its muslin case. Barefoot and still in pajamas, you walked together to the river at the break of dawn. You stuffed the cat in the pillowcase, and, with the long piece of rope still circled around its neck, you tied the bag and swirled it until the cat stopped meowing and moving. It was only a few months old. In the river, the thin rope flowed from the muslin sack like an umbilical cord in the water.

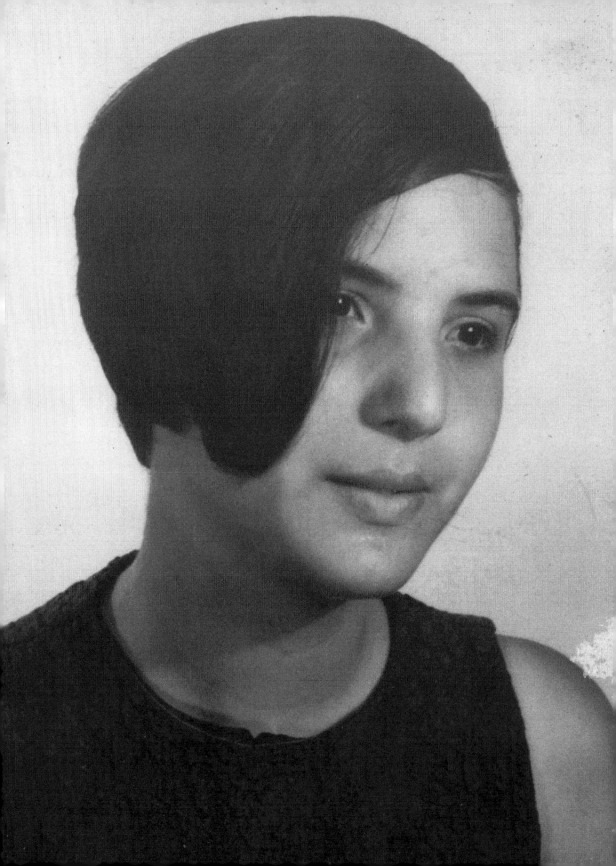

EL CUCO

MY COLLEGE TEACHER IVONNE identified El Cuco as the root of the problem fifteen minutes into our conversation. She was disruptive from the moment she stepped into our classroom in her moccasins, baggy pants, and loose button-down shirt, standing out from the rest of us in our tight jeans and high heels, a favorite outfit for women en la isla. Ivonne transformed neuropsychology from an intimidating science to a fascinating neural net in our brain connecting us to the outer world. In her lectures, she personified each brain component as an individual entrusted with specific tasks. The hippocampus: receiver of the hormones pulsing through our bodies when faced with a stressful event. The cerebral cortex: meticulous archivist of our long-term traumatic memories. The amygdala: exhaustive repository of our emotional memory and conditioned fear. It was while we were studying trauma and its effects on the brain that I decided to switch majors from psychology to medicine, despite being at the top of my class.

Ivonne summoned me to the privacy of her office. "Medicine? What's going on, Erika? You're doing so well in psychology."

"I want to do something more useful," I replied, "to help more people. I don't think I'm doing enough with psychology."

Smelling my bullshit from across her desk, she asks about my living situation. I tell her I live with you and H. She asks how it is living with you both. The walls in her office are flimsy and I wonder if people in the waiting room outside can hear our conversation. I remain silent but my eyes begin to sting. I tell Ivonne that I don't think you love me. When she asks why, I tell her that you are angry at me all the time. Then she asks about H. I tell her things are fine now, but she wants to know how they were before. "Malagradecida…" I hear your voice start to echo in

the back of my head. I tell her H used to touch me in the mornings, but that it hasn't happened in years, since I started waking up before him. I want to tell Ivonne that I told Tía D—your sister—when I went to visit her in Inwood some years after it happened, and that she got really pissed and confronted you. But I feel too embarrassed to have to add that you told Tía D it was probably me provoking H, so I keep quiet. I just tell her that you hit me when I am upset or when I cry. That when it starts, a demon engulfs you, your eyes leave the room, and you don't finish with me until all your anger is gone. "Malagradecida" now louder in my ear. The walls of Ivonne's office dissolve and now everyone in the waiting room is a captive audience.

Ivonne's face reddens; a thin snake pulses under her skin from her hairline to her right eyebrow. In her Cuban accent, now thicker, she asks me, "Do you ever get angry? Have you thought about standing up to your mom? Have you heard of El Cuco, the ghost that makes disobedient children disappear?" My eyelashes are wet clumps. She holds my hand, places a few strands of my peroxide-blonde hair behind my ears, and tells me, "Maybe psychology is forcing you to answer these questions."

•

"IF YOU COULD VISUALIZE your personal boundaries as a fence, what would that fence look like?" asked Coni a few months back as we inched closer to discussing my anxiety and my inability to set limits. I pictured a fence around a house by the sea. It was windy and the sky was the silvery blue of those moments before it heavily rains. The fence was anchored in the sand and surrounded by tall beach grass that swayed in the wind. The fence swayed too, malleable and transparent, its panels made of the same sticky material as the elastic bands sewn inside cheap dresses to prevent them from slipping off the hanger. Between the slabs, the icy air funneled its way toward my face, making my eyes water. Through the transparent fence, the blurry outline of the house was shaky in the wind.

●

LET ME TELL YOU what happens to me when you hit me. When the memory of your hands on my body is not of an embrace but of raised crimson welts on my skin, I sit across from a man on a date, decades later, making a long list in my head of why I'm not good enough for him.

Saúl and I met on Tinder during the first months after the app was released. I had a set of rules that I thought would offset the casual nature of the app. The men had to be the ones to message me first; we had to chat some before meeting in person; they had to be the ones to set up the first date, as if by coercing them to make an effort I could alter their intentions. I was surprised when he bypassed the Tinder chat and asked for my phone number instead. He called a few seconds later. It saddens me to remember how exhilarated I felt receiving a phone call instead of a text, how women in Nueva York have become grateful for even the most rudimentary efforts by men. We spoke in Spanish. I learned he was from Madrid and liked films. We commented on a documentary about Anna Wintour released that year, *The September Issue*, and I was touched by his openness when he said he identified with her, that by choosing to work in advertising, he felt he had disappointed his father.

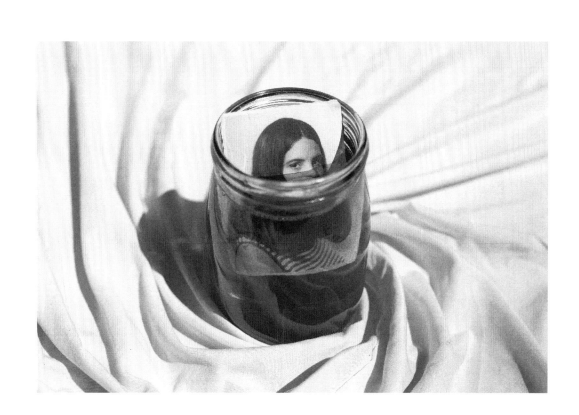

Across from me in the upscale bar he chose in Soho, he is soft-spoken and listens attentively. We are both single parents, each with a young son. We exchange stories about our fathers, his dying of leukemia, mine at the hands of the Dominican government. His presence feels refreshing after years of going to bed with men I've hardly spoken to or spent time with. He mentions that my body language changed when he asked me, "¿Y tu madre?" My shoulders cave in as I tell him we haven't spoken in a few years, the space between our wooden stools suddenly smaller.

I am see-through.

When the date reaches its end and I see a glimpse of the kind of man I would like in my life, I repeat in my head what I told myself in the mirror before I left my apartment in Queens: "Do not sleep with him. You don't want sex; you want a relationship." But when he asks me if I want to continue the date at his apartment, I say nothing and hop in the back of a cab with him.

I am mute.

This is the same silence I held when a guy I was dating years ago told me he wanted to take me to the beach at night. I packed up my guitar, got in his black Jeep, and saw it head in the direction of his basement apartment instead, a place where he undressed me in front of a mirror and didn't let me leave for two days, with hardly any food. I experienced this exact muteness when another man I was dating slapped me across the face during sex, and when a third one, whom I had traveled all the way to Los Angeles to see, came in my face when we had sex upon my arrival. On these three occasions, I had kept silent and pretended nothing was wrong. But now, naked in Saúl's bed, softened by our night of deep conversation, I begin to cry while we are having sex. He is startled by my crying and is kind enough to pause and inquire about what is wrong. I mutter that I didn't want to have sex so soon. He asks me the

question I seem unable to ask myself: "Why did you agree to have sex if you didn't want to?"

I am damaged goods. An easy fuck.

The morning after, I wake up before him and sit at the edge of his bed, naked. The floor-to-ceiling windows in his luxury studio apartment overlook other glass-and-steel buildings in the financial district of Manhattan. I see a tall glass vase filled with wine corks on the dining table, which I take as evidence of moments he's spent with other women who were worthy of time over wine in his home instead of drinks at a bar followed by sex, like me. In front of his bed is a black Eames leather lounge chair, and next to me at the foot of the bed are the $29.99 black pleather booties I purchased at Marshalls on the occasion of our date.

I am cheap and unrefined.

When he wakes up, he refuses my offer to go for coffee and croissants. After this day, we only see each other one more time, to fuck, when in a moment of weakness, I text him from the movie theater while watching *Blue Is the Warmest Color*, the raw intimacy of the film further disarming me in our interactions. I never see him again. I am not worth another phone call, or a second date.

I am not good enough for him.

Something else also happens to me when you hit me. Throughout my adulthood, I seem unable to set roots anywhere, an urge to escape rising inside me every time I choose a place and try to make a home. I've put countless hours and love into renovating this apartment in Jersey City, but instead of learning how the light falls at different times of the day on its white walls, I go on Zillow to look at other homes in Europe, in California, in Mexico City. I imagine myself living anywhere but the place where I currently am. I create Google documents with lists of places I would like to move to when Amaru goes to college, although I don't

know anybody there. Some of the documents list places to go study a foreign language; others enumerate a list of countries for a one-year European road trip—maybe, I think to myself, I need a more extreme uprooting, one that happens every few weeks. I can't relax anywhere.

I am placeless.

Instead of the soothing cradling of a mother, the abrasion of your hands on my body or their pervasive absence—the extreme opposites in your mothering—have created in me a perpetual sense of instability. This instability feels like the scene I've seen so many times when I take the subway late at night in Nueva York. Sitting on an empty subway car, a homeless person is performing a balancing act of holding in place their belongings on wheels—usually a grocery cart or an old suitcase—and trying to sleep at the same time as the train rattles below them, impeding them from accomplishing either one. They clutch their belongings as the floor sways below them; they have to remain vigilant when what they really want is to rest.

You are the third rail beneath my feet, always vibrating with lethal electricity.

●

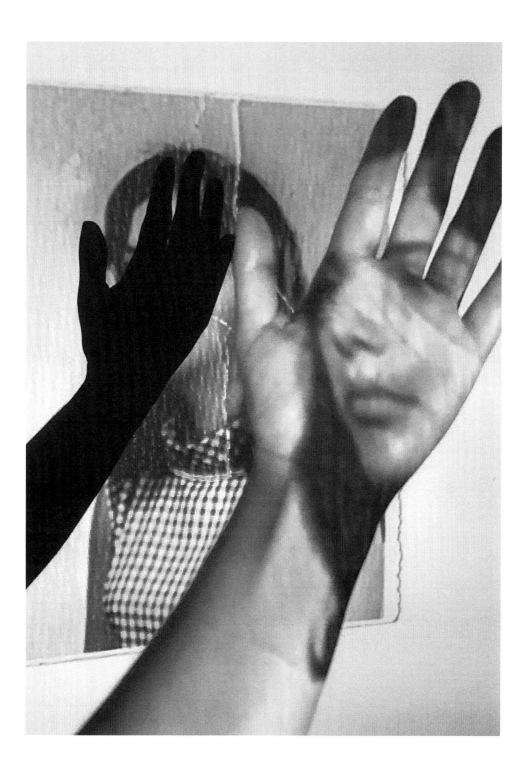

I **WOKE UP TO** the familiar sensation of suffocating. It was a few minutes shy of 6 a.m., and the morning was still gray outside my bedroom window. At first, I thought I was having a bad dream, but when I sat up and heard the loud wheezing, I knew I was having one of the bad asthma attacks that require me to go to the hospital and get a shot. I went to your bedroom and knocked on the door. You always locked it at night before going to bed with H. "Mami, no puedo respirar. I think I have to go to the hospital." Your exact words escape me; I just remember your yelling ringing in my ears, "Muchacha de la mierda, waking me up so early." You walked away from the door and went back to bed.

Maybe it was true that at nineteen, I should have been able to solve my own problems. I paced to the kitchen, trying not to make my breathing more laborious. I heated some water in the pot we used for making rice at home every day and when the steam ribbons started rising, I dropped two spoonfuls of Vicks VapoRub in the scalding water and took the pot to my room along with a kitchen towel. I placed the pot in front of me on the bed and sat up straight. The room spun around me, another sign that the episode was serious and my inhaler would be useless. I made a steamy cocoon by placing the kitchen towel over my head and lowering it to the pot. The wafts of menthol felt abrasive against my skin and on my throat, but they helped. I inhaled until the wheezing receded and the flowerpot on the dresser in front of me stopped moving. An hour passed as I rested my back against the wooden headboard and took long breaths through my nose until it was time to take a shower and go to work.

I was still lightheaded when I made it to the preschool, where I worked as an English teacher in the morning before attending my classes at college in the afternoon. My shirt was glued to my back in the humid June weather as the summer approached and with it the end of the school year. The kids rushed toward me, hugging my legs and pulling on my pants to tell me the English words they had practiced at home. They

had been exhilarated the day before when I brought a basket with some basic fruits and passed them around as I taught them their names in English: banana, orange, apple, lemon, and what proved to be a favorite to pronounce, estroberi. As I walked toward the classroom, the schoolyard became only yellow flashing lights and voices calling my name in the distance.

I woke up on the couch to your scolding. Two of the school employees brought me home after I fainted. It seemed my menthol remedy had only opened my respiratory tracks temporarily; still not enough oxygen was entering my body.

"Let's take you to the hospital now," you growled at me, a mix of concern and annoyance in your voice.

"I don't want you to take me anywhere. I will go by myself," I snapped back. I saw you approach the couch spitting insults, your eyes rapidly blinking, as you usually did before hitting me. My body felt as if it were made out of Jell-O, but somehow I managed to get up from the couch and raise my hand at you: "If you hit me one more time, I will fucking hit you back. I don't care if you are my mother!"

I felt my hands shake in clenched fists as tears rolled down to my chin. I held your stare until your eyes pooled around their corners. Until your chin began to shake—the way it does just before you cry—your shoulders slumped, and your heavyset body walked away from me.

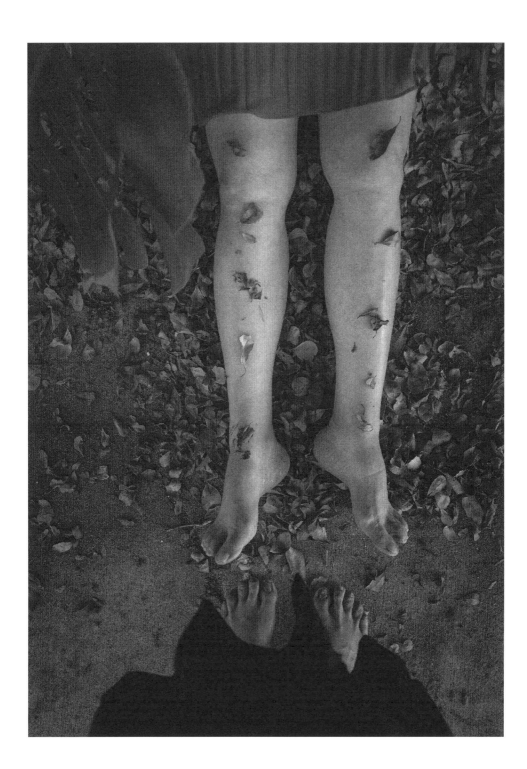

THREE

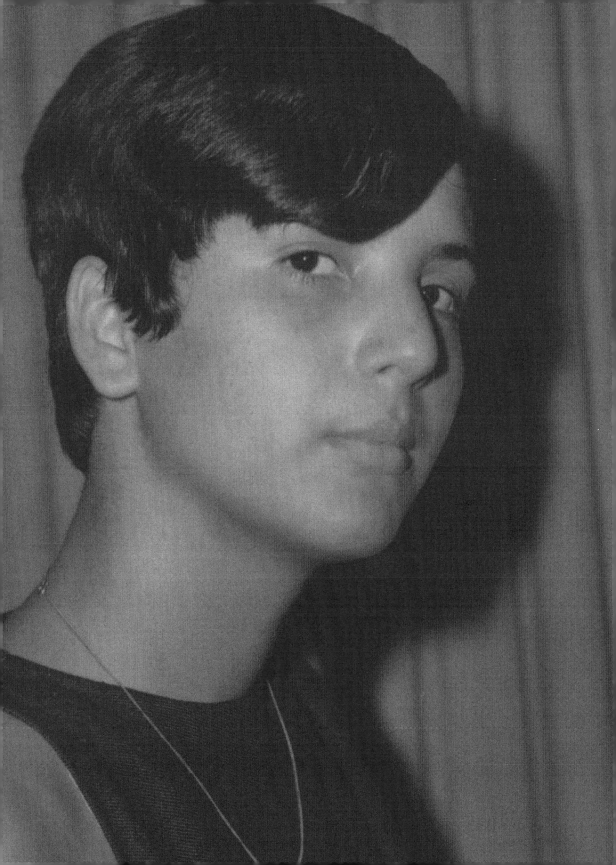

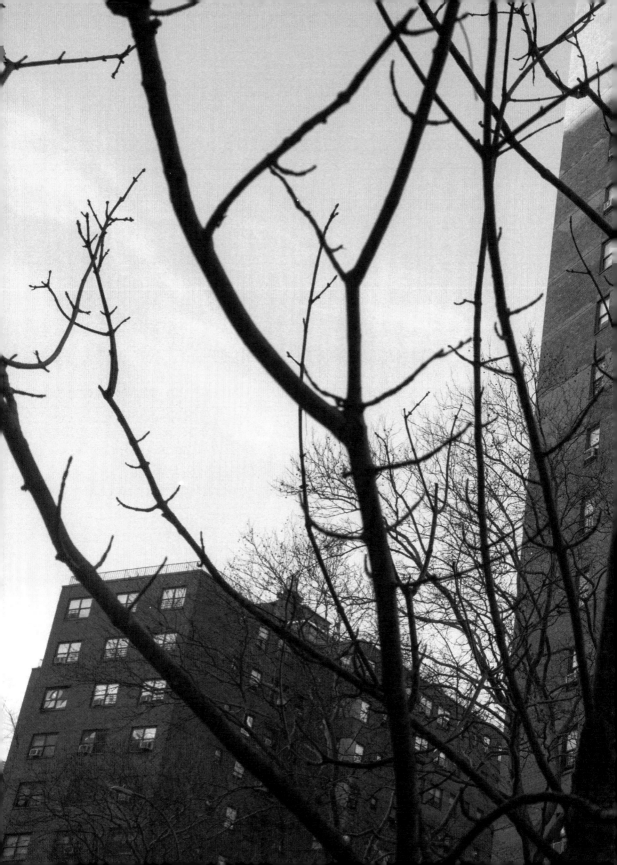

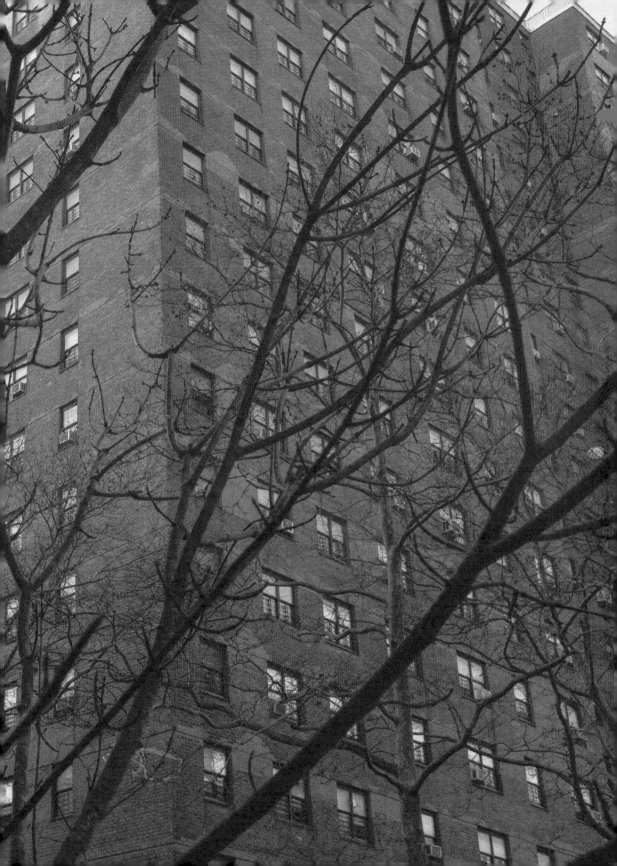

NUEVA YORK

TÍA B WAS THE ELDEST and the first of the Echavarría sisters to leave la isla, after your parents received a letter from the presidential palace inviting her to attend a party there. It was the late '50s, Trujillo was still in power, and your parents knew this invitation was an official, nonnegotiable request to offer their teenage daughter to the president. Trujillo's lookouts would lurk in the cities and remote towns, scouting suitable candidates for him. He liked them white, and Tía B, with her straight black hair, button nose, and alabaster skin like the Corelle china we had at home in Santiago, was perfectly suited to his desire for whiteness.

This desire made him do unthinkable things. He orchestrated the genocide of thirty-seven thousand Haitians by machete in 1937 during the Parsley Massacre to stop their blackness from seeping into our half of the island. The word *perejil*, Spanish for parsley, was a foolproof method for identifying Haitians passing as black Dominicans—those who said it with a Creole accent got the machete. He also signed a treaty with Japan in 1956, taking advantage of the horrors it faced after World War II to bring more than two hundred Japanese families to la isla for agricultural labor. He proclaimed the Dominican Republic as one of the countries helping Japan improve its international reputation, when in fact he was after their fair skin to help whiten our country, to mitigate the blackness coming from Haitian migration. Trujillo was a man who would rather slaughter his neighbors and look for new ones across the world than watch his country become blacker.

His misogyny and racism carved the first inroad for our family's migration to the United States. After the letter, Tía B was sent to Puerto Rico to stay with an aunt, and after your parents died, she was shipped again to the Bronx, where she married a Dominican man. When Tía M

went to visit her sister in her apartment at 847 Hunts Point Avenue in the Bronx during the '70s, the sanitation workers in Nueva York were on strike and piles of garbage lined the sidewalk like small buildings. The smell of trash outside was followed by the smell of pee in the building's hallway, where squatters had taken up residence to escape the cold winter. Tía M decided to change her flight from two weeks to only a few days after she got up in the middle of the night to get some water and saw a swarm of tiny German roaches moving from the kitchen wall to the cabinets, the wall changing from brown to beige in just a couple of seconds.

Tía M did not know she would soon meet a similar fate. In 1979, Hurricane David tore la isla to pieces, destroying the restaurant and gas station she and her husband depended on for income and prompting them to move to Nueva York to work in a factory. When Tía M visits me, I can sometimes see the thin, shiny scars on her upper wrists, a souvenir of her twenty-five years of repetitive labor in the factory, twisting bottle caps closed on Elizabeth Arden and Esteé Lauder beauty products, forcing her to have carpal tunnel surgery and go into early retirement.

Tía D, the only one of your sisters who was still unmarried, also decided to migrate to Nueva York in the '70s. It wasn't hard for her to get her visa to the United States, as she met the initial and most important predictor of success for this procedure: skin color. The only blonde out of the four sisters, with straight hair down to her waist and milky white skin like the ceramic figurines of cherubs and Victorian ladies she now collects, Tía D was fast-tracked to the Bronx to live with Tía B and got married to another Dominican man in the city. Out of all the places of my relatives I visited while growing up, her small apartment in Inwood was the only one that ever felt like home.

●

A ROUND WET SPOT dotted my white T-shirt underneath my right armpit as I walked off the airplane at JFK. Mango juice had dripped from one of the two large plastic containers holding the one hundred peeled mangos banilejos you sent Tía D that first summer I spent with her in Inwood. This was one of the perks of traveling to the United States before 9/11; in the '90s, you could smuggle any food from la isla in your hand luggage. Football-sized avocados, frozen pasteles en hoja, dulce de leche con coco in repurposed plastic jars, their lids double-sealed with tape. I was fourteen and it was the summer of 1997, the first of many summers you would ship me para los países so you wouldn't have to deal with me and could enjoy life with H in peace.

The night I arrived at the apartment on Vermilyea Avenue, I sat silently across from Tía D at the round table that took up most of the small kitchen and watched her devour dozens of mangos one after the other with her eyes closed, the white skin on her face, hands, and forearms wet and tinted a pale orange. "You can't get mangos like these in Nueva York. The ones we have here are all ripened with carbide and taste sour." After she ate almost one whole container, I listened to her talk to you on the phone, telling you how delicious the mangos were, as she pulled the thin fibers stuck in her teeth. This was my favorite place to be in the apartment, sitting at this round table observing Tía as she talked on the phone all day, made foot-long mozzarella grilled cheeses in her large black sandwich toaster, and stirred pots of yellow rice with pigeon peas. The sensations of this tiny kitchen lulled me. The soundtrack of Univision or Telemundo in the background alongside the slew of gossip I overheard during her phone conversations; the heat from the stove; the faint humid breeze entering the kitchen from its only window; the sweat collecting on my forearms as I rested them on the transparent plastic covering the flowered tablecloth, the same kind that covered the baroque-style oak couch and armchairs in her living room.

The apartment housed six people, seven during the summers when I visited. It was a two-bedroom apartment, but when my cousin G—the only girl out of Tía D's four children—began developing, Tía put up a plywood partition in the kids' bedroom to give G her own room. G's makeshift bedroom was five feet wide and fit only a twin-sized bed and salon-style hair dryer chair, upholstered in a beige vinyl that in the summer was its own kind of purgatory. The backs of your thighs and knees would sweat profusely against the plastic, and the bobby pins holding the multicolored hair curlers to your head would heat up like coals and burn your scalp. There was no respite from the heat as your hair dried in the windowless bedroom. In the forced physical intimacy created by this minuscule space, G and I took turns drying our hair, did sit-ups on the sliver of empty floor between her bed and the plywood wall, and blasted romantic salsas by La India as she confided in me the guys she would see in secret, behind Tía's back, although G was in her first year of college and had the right to date as she pleased.

The wall opposite the hair dryer had stacks of shoeboxes reaching the ceiling, mostly sneakers and boots, some of which I watched G buy at V.I.M. on 207th Street. I looked up to G and envied her looks, her slim and muscular frame, tiny waist, and peach butt like the store manne-quins uptown in Nueva York. She modeled my hair after hers on week-ends, taking a glop of green gel and slicking it back into such a tight ponytail that my eyebrows arched and I looked surprised at all times. A faint headache lingered in my temples for hours after I took off the hair tie.

After Tía made dinner and yelled for us to get our plates from the kitchen, my four cousins and I would bring the food to the bedroom and watch MTV. We'd watch music videos—Missy Elliott, Boyz II Men, Salt-N-Pepa, JLo—but our favorite show was *The Real World*, which

took place in Boston that year. American TV and conversations with my cousins made my English sharper every summer. Dominican Spanish cannot be literally translated, I learned, when my cousins and I were having dinner one night while watching TV and someone farted. The hot, small bedroom and the five of us crammed into two beds made it worse. Since I was the rookie, they blamed it on me; I scrambled for my words in English to swear on you that it wasn't me and blurted out, "I promise to my mom I didn't throw the peo!" Tears ran down my cousins' cheeks as they choke-laughed for a solid ten minutes while I sulked over my plate of moro con guandules. In this stinky bedroom, being teased and huddled together laughing with my cousins, I briefly remembered what it felt like to have a family. A pinprick piercing of light in the black void that stands in place of life when Papi was home.

•

AT TIMES, YOUR EFFORTS to get rid of me turned out to be your biggest gifts. In sending me away every summer during my teenage years, you unknowingly gave me a second home, Nueva York, and a second mother, Tía D.

The minute I'd arrive at her apartment from la isla, Tía would reach for the top of her closet, take down a folded black duffel bag on wheels, and bring it to the living room. We only entered the living room on special occasions—when she had visitors, when she placed a new antique ceramic figurine on the oak side tables, or when she put the bag next to the white scale underneath a long side table at the beginning of my trips. I'd arrive with only mangos under my arm and leave with a bag jam-packed with new clothes, shoes, and school supplies. Tía and I would scan the discount stores in Inwood and Washington Heights during the week, and on weekends we'd make the trek downtown to Chambers Street, where we bought contraband clothes in the back rooms of the factories where they were made. I had a talent for finding great jean shorts, pants, and overalls, while Tía spotted the best T-shirts and polo shirts for my cousins. When we came home, we'd sit on her plastic-covered fancy couch, fold my new acquisitions, and place them inside the black duffel bag. Tía would weigh the bag and state how many of the fifty pounds of allowed luggage I still had available. "You still have forty-three pounds," she'd declare. Without her having to say it, I knew Tía loved me because she parked my maleta in her living room among her precious collection of ceramic figurines. There it stood all summer, a growing black centipede next to the antique lamp whose base displayed a lady in a Victorian dress, resting in a green meadow underneath a parasol. Inside her living room, our shared bucolic landscape.

●

IN CONTRAST TO YOU AND ME, always inhabiting different corners of our large house in Santiago, during these summers, Tía D and I did everything together. Through our daily routines, I began experiencing things that would always make me associate Nueva York with the elusive idea of home. I'd wake up to Tía already washing a load of laundry in the ancient washing machine she somehow installed next to her sink in the kitchen. "¿Cómo dormiste, Erikita?" she'd say as she stirred two spoonfuls of Maxwell House instant coffee in a steaming cup of milk followed by two spoonfuls of sugar. Light and sweet coffee, a treat I still prefer over the fanciest drips or espressos anywhere in the world. To save money, Tía would wash her clothes at the apartment, stuff the wet clothes into laundry sacks and then into a grocery cart, and haul it down the five flights of stairs and two blocks to the laundromat on 207th Street. I wondered, as I helped her drag the heavy cart down the stairs, how she did this by herself the rest of the year. Tía D's hands were rough to the touch, her nails short and unpainted, the meaty thickness of her fingers always adorned by a chunky gold ring on her pinky. I inherited your hands, baby soft and with small and slender fingers. In the '90s, I remember your long, manicured nails were always painted a different shade of red.

As we were drying clothes one day, the Chinese owner of the laundromat came out yelling from the back of the store and threatened to forbid "all you Dominicans" from using the machines as he fished from the slots the Dominican twenty-five-cent coins, the same size and shape as American quarters but worth only a meager fraction. Tía kept her eyes on the clothes swirling in the dryer while he yelled, but as the man turned his back, she and the other Dominican women doing laundry shared a knowing grin.

When I saw Tía filling her canteen with the oblong cubes that her fridge released through the ice dispenser, I knew the time for our afternoon walk was approaching. She would put on her white Reeboks and

shiny black leggings and wrap her belly with a foam band she saw in an infomercial that guaranteed weight loss around the waist. The ice cubes in the canteen strapped across her chest were the soundtrack of our walks as we jogged from her apartment to Inwood Park and then up the hill overlooking the Hudson River, me always a few steps behind her. A few days a week, we would finish our workouts at the home of her friend Waleska, a red-headed Puerto Rican woman who gave free aerobic classes to other women in the neighborhood in her basement apartment. I was always the only teenager in a group of loud middle-aged women, vigorously moving their soft, slightly overweight bodies to the rhythm of Puerto Rican salsas, the room stuffy with the smell of fruity body lotions and sweat.

A few weeks after I arrived that first summer, Tía came up with an idea. Although I was only fourteen, I could easily pass as a sixteen-year-old and get an under-the-table job in the neighborhood. After asking around, a friend told her they were hiring someone to do nails at the Hair-matics salon on Broadway and 207th Street. I'd never done nails before, but I practiced on Tía the night before, soaking her feet in a ponchera filled with warm soapy water, scraping the calluses around their edges with a Dr. Scholl's foot file, and painting her toenails a pearlescent pink. I was a natural, Tía said.

Since she was often tired at the end of the hot summer days, I offered to give her massages. As she lay face down in her bed, wearing only her panties, I massaged her with a menthol cream that smelled faintly of Vicks VapoRub. Under my hands, the muscles of her unshaven calves were still throbbing from going up and down the five flights of stairs several times a day, and her neck and shoulders felt like one tightly knit braid, which I helped undo by pressing my thumbs hard at the nape of her neck and sliding them down her shoulders until I felt the knots pop underneath my fingers. At the end of my massages, the throbbing had

transferred from Tía's tired muscles to my hands. I felt so useful. She said I was also a natural for massages, and a week later she got me a gig massaging her friend Tati across the street, an overweight Dominican lady from El Cibao, who spoke in a loud singsongy voice and laughed whenever I massaged near her protruding belly. She paid me twenty dollars per session. Dominican Yorks, I learned, had a natural ability to turn even the slightest skill into a side hustle.

The work at the salon was easy—mostly quick manis and pedis—with the exception of the flamboyant hairdresser who complained to me about an ingrown nail bothering him. I braced myself when he removed his leather cowboy boots and plopped his sockless, sweaty foot on my lap, his right big toe red around the ingrown nail. After dousing my cuticle cutter in acetone, I inserted it underneath his toenail and cut the piece of nail that was digging into his skin, its smell something I have only encountered again when entering the pungent acridness of specialty cheese shops. That first week of work, between the sixty dollars in tips from the salon and the twenty dollars from massaging Tati, I had my first official Nueva York paycheck and a taste of the hustle. I had yet to think about what I wanted to do with my money when Tía asked me to put it in an envelope and walk with her a few blocks to the closest Western Union to send it to you en la isla. She congratulated me: "Erikita, tu primer envío a Santo Domingo." I had been initiated into what it meant to be a good Dominican daughter living in Nueva York.

•

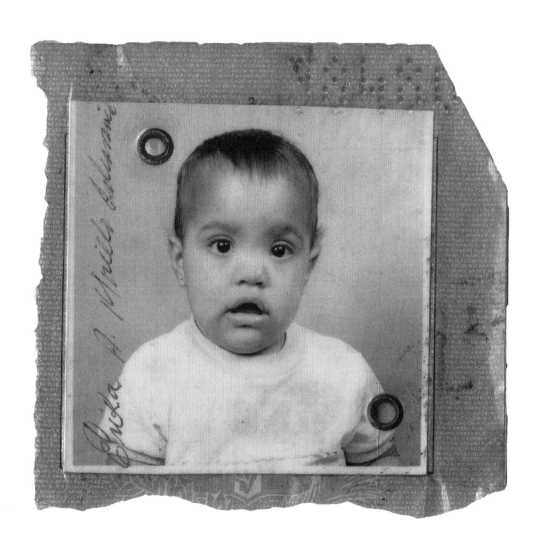

THE NIGHTS IN INWOOD were the most peaceful. Tía and I would change into our nightgowns—I wore her old ones that were a little big on me but small on her, white and always sporting some flower design on them—walk out of her building past 9 p.m. when the heat emanating from the pavement had receded, and head to the donut shop on Broadway. We always got the same thing, twelve donut holes dusted with coarse sugar. We'd sit on the benches on the outskirts of Inwood Park, eating mouthfuls of doughy sugar, the brown bag turning translucent from the oil the donuts were fried in. Tía would always sigh and say the same thing as she ate the donuts, eyes closed, in the cool night breeze: "¡Qué frequito má' rico!"

Today, when I visit Inwood and walk by those benches next to the park, I am overcome with gratitude to you for putting me on that plane and giving me an inroad into this city. A glimpse of another life possible. The close proximity to other bodies, the cramped spaces, the city smells exacerbated by the summer heat, and the bodily efforts required to carry out daily chores in the city comforted me and overshadowed the aseptic loneliness of our privileged life in Santiago. Of our verdant backyard filled with fruit trees; of our fancy living room with freshly upholstered couches and Italian crystal vases; of my balconied bedroom overlooking Papi's coconut tree, all beautiful spaces that do not hold a single memory of you and me ever embracing. I thank you, because in those brief summer months when you released your grip on me, you gave Tía D and me an opportunity to survive both our islands.

"HOW CAN YOU live like this? All that studying to end up in this shithole?" my brother asked when he visited from Miami in 2006 and saw my first apartment in Nueva York at the corner of 106th Street and Lexington Avenue. While it was true that you couldn't go to the bathroom at ease because the toilet was too close to the wall and the cold tile pressed against your butt, I loved my apartment. After several weeks of intense searching, I had made it. I was twenty-two and had my own apartment in Manhattan for less than a thousand dollars a month—nine hundred and ninety-five, to be exact.

Upon arriving at the front door of my building in Spanish Harlem, four smelly trash cans would be your welcome. The stairs were steep and creaked underfoot like an old boat. Four floors up was my studio apartment, a tiny space where you could get from the kitchen sink to the sofa in less than three steps. I decorated my tiny place in shades of pink and light blue. The closet had no door, so I improvised one out of an old navy-blue bedsheet and fastened its corners with two plastic sunflowers I got at the dollar store on 103rd Street.

In the mornings before heading to work, I'd wait in line at the deli across the street for a toasted sesame bagel with cream cheese and a regular coffee—light and sweet—as a swarm of loud high school students bought breakfast and snacks on their way to school. On Saturdays, I would gladly climb all four floors with the weight of grocery bags slicing my fingers and my heart pounding out of my chest. I would lie in bed to catch my breath and look at the yellow watermarks on the ceiling above me as Héctor Lavoe blared outside. I was home.

Fifteen years later, still living in Manhattan and holding down multiple jobs to be able to pay $2,750 a month for my one-bedroom apartment, I find it hard to call Nueva York home. I ask myself the question I've never had the courage to ask you: How can home be this hard?

I wake up on the daybed, an improvised piece of furniture I devised by piecing together my son's toddler bed with the backrest and cushions of my old IKEA couch, the only pieces that made it unscathed by my cat's claws. A tiny contraption where my arms and feet dangle outside the frame as I sleep. Amaru, now a teenager, sleeps in the bedroom. When I start remembering things, the bedsheet over the couch grows deep creases where my body lies, developing the smell of unwashed hair, the stickiness of wax. From the daybed, I start threading my long list of shortcomings. I start to recall my first days in this apartment, when my happiness about living in this beautiful downtown neighborhood by the Hudson River was quickly overshadowed by the sound of mice late at night, chewing through my garbage bags and the bananas on the countertop. I spent a whole day cramming every crevice of the apartment full of steel wool until the tips of my fingers were bleeding and I couldn't tell if I had cut myself or crushed a tiny mouse in one of the holes. If I'd stay up late at night reading, I would hear the mice chewing their way in from the baseboards. My chest gets tight and I feel you in my home, making yourself a nice cup of tea while I hear you say the words you told Tía D after I left la isla for Nueva York. You told her you disapproved of me moving out on my own in Manhattan because you knew I just wanted the freedom to take men home as I pleased, that it would not be long before I got pregnant and fucked up my life and all you had given me.

I drag myself from the daybed to the tiny kitchen—a space my best friend joked was smaller than a dollhouse kitchen—to make coffee. I chop up some mangos and put them in my favorite Japanese lacquered bowl, painted with pink sakura flowers. The sliver of light filters through the window into my living room. I have counted its duration many times before and realized it enters my dark apartment for a total of seventeen

minutes. I take a chair and place it right next to the window, sipping my coffee under the thin line of sun that manages to warm a fragment of my forearm. I tell myself this is nice. In the brief moments when the street-light turns red and the cars outside my window are stagnant, I can make out the faint sounds of birds in a nearby tree. One or two chirps before their sound is drowned again by the moving wheels. A meager fragment of the lush tropical backyard in our old home in Santiago. From a corner of the windowsill, my cat wags his tail at pigeons down on the sidewalk. The sliver of light leaves my forearm and hides beneath London Terrace Gardens, the tall, expensive building across the street. My home goes dark again, and I've lost my appetite for mangos.

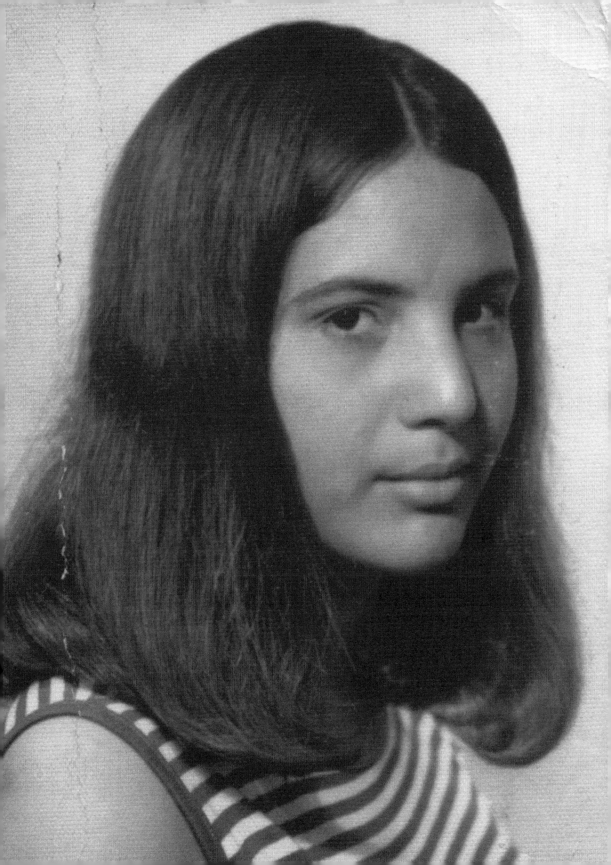

GIRDLE

"MAYBE IT WAS THE GUITAR," I said to Coni, piercing through the minute-long silence after she asked me to share my happiest memory of you. My high school principal summoned me to the main office through the speakers. I made my way to the front of the class, pushing the boys who were shouting that I must have been a naughty girl. When I got to the office, you were there, crying as you stood up from the chair to greet me. You were holding a tall box in the shape of a triangle. "Feliz cumpleaños, mi hija," you said as you pushed the large triangle toward me. My peeling through the cardboard box only made you tearier, and when the tuning pegs and strings appeared as I opened the top, the salty stream was already tickling the back of my nose.

You knew I was borrowing guitars from friends and taking them home over the weekends. Our house grew calmer as I practiced the same few chords in the solitude of my room, and I think you and H enjoyed the music. When I ran out of chords to play, you took me across the city near El Malecón for guitar lessons. I learned snippets of songs by Eric Clapton and the Eagles, but it was the church songs like "Paz en la tormenta" and "Nadie te ama como yo," which I learned in their entirety, that helped keep the animosity at bay between us. The cinder block pressing on my lungs would briefly levitate as I played the notes. I was terrible at the guitar and annoyed my friends by playing the same half-dozen songs, including a song I wrote for our high school's anniversary, which they still sing to the beat of an invisible guitar every time they see me. I imposed my guitar and bad playing everywhere I went, and all the mocking and eye-rolling could not dampen the joy it gave me.

I clung to it like an identical twin. Like a life raft.

I polished it with the lemon-scented oil you rubbed on the caoba furniture to protect it and keep it shiny.

I asked for seventy-five dollars when, during one of our periods of estrangement, I put it up for sale on Craigslist.

Our inability, yours and mine, to keep reminders that could complicate the grudges we held against each other.

●

DURING THE INTERVALS of time when we stopped speaking to each other—the longest lasting seven years—I watched you age at a distance, on the photo prints you sent to me in Nueva York, directly or through my aunts. The photos show your shiny, healthy hair turning coarse and porous after decades of bleaching, your body becoming rail thin and then plumping itself at such a speed so as to become unrecognizable by my best friend's mother, who ran into you while paying the electric bill in Santo Domingo. You had to remind her that you were my mother. I wonder if reminding myself of this fact would be a fruitful exercise for me as well.

As a teenager, I was told about your plastic surgeries by the chauffeur who took you to the clinic and brought your bandaged body back home. I was not allowed in your bedroom until your torso and face had healed into their more compact and smoother shapes and the bruising had turned from a scary purple and blue to a subtle yellow. I asked you what happened to you and why you were at the hospital, but you avoided my questions. During the following weeks, in the glimpses I caught when you weren't looking, I noticed your right eye beginning to droop, the fleshy pink inside of the lower eyelid showing at all times. A pink half-moon permanently lodged underneath your eye. Nobody told me, but I believe this was the outcome of a failed eye lift that, instead of making you look younger, as you intended, emphasized your sadness.

Why do you insist with such fervor on hiding yourself from me? When I mentioned to Tía M that my eyes were dry due to working long hours on the computer, she suggested that I hydrate and take good care of them to avoid becoming blind in one eye, like you. As I revisited the photos I made this year, I found a self-portrait I took a few months back, before I learned about your blindness. In the photograph, your image is projected on my bare chest, my hands caress your face, and my middle finger replaces the eye from which you can no longer see.

·

MY HUNGER FOR YOU GREW LARGER. Unable to get to know you directly, even during the years when we lived under the same roof, I sought to understand you by asking your sisters about you when I moved to Nueva York. Tía M is the one I turn to in order to hear, with laser-sharp detail, the many anecdotes from when you came to visit them. I am ashamed to admit that the stories where your vanity got the best of you are the ones I crave most.

It was the early nineties and you traveled to Nueva York to attend my cousin J's wedding. You were in one of your overweight periods, but when Tía M and Tía B took you dress shopping for the wedding at Lord & Taylor, you insisted you were a size eight, leaving the store empty-handed and saying American dress sizes were smaller than the ones back on the island. Nonetheless, you were determined to fit into a medium size. The next day, you went and purchased a girdle from the Cuban lady's store at the Freeport mall before going dress shopping with your sisters again. I guess it's easier to jam large things into small spaces than it is to take them out, as evidenced by funny rescue videos where kids stick their heads between two poles or into small openings and have to endure the shame of a firefighter liberating them. Despite the logic of this, I can't explain how you fit your two-hundred-pound body into a

medium-sized girdle. When Tía M and Tía B came to pick you up, you were sitting at the kitchen table, uncharacteristically quiet and about to faint. Tía M was the first one to notice your face and upper body turning the color of plums from the girdle cutting off your circulation, shouting, "¡Se está poniendo morada!" Tía M stormed upstairs to look for her husband and son to pull the girdle off. Tía B suggested they cut it, but you refused as you lay immobile on your back on the kitchen floor, saying it was expensive and you were going to return it the next day. My uncle and cousin each took one edge of the metal-boned girdle and pulled it down with all their strength, but your body just slid across the kitchen floor as my aunts yelled suggestions from the corner of the room. It wasn't until Tía M's daughter joined in and held you by the armpits as both men pulled it in the opposite direction that the girdle finally came off, leaving a trail of bruises where the wires dug into your skin.

In the photographs I've seen from the wedding day, you have a frizzy blonde bob and are wearing a boxy pink dress with a big bow on the right hip, which Tía M said would distract the eye from the stomach area. Judging by these pictures, the dress size was at least an extra-large.

●

DESPITE YOUR HIGH-MAINTENANCE NATURE, you were a bottomless source of delight for our family during your visits—as long as they readied their pockets. Everyone knows you are an excellent cook, but your talent for making desserts is otherworldly. You deserve this hyperbole. My cousin M begged you to make her your famous flan, which you agreed to do but said it would cost twenty-five dollars to make. Thirty years ago, that was a lot of money for flan. When my cousin protested, "Pero Tía, isn't flan just eggs, milk, and sugar? How can it cost twenty-five dollars to make?"

"Decorations," you replied, and already savoring the flan, my cousin forked out the money.

When she came home from work, she found the flan in the fridge, perfectly creamy and covered in caramel, atop it the pricey decoration you had insisted on: a single plastic flower from the dollar store.

The only thing you did for money that was cheaper than your flan was your reading in English, for which you charged twenty dollars. My cousins would all gather in Tía M's kitchen and take turns bringing items with words on them so you could read them out loud in your nonexistent English. The Colgate toothpaste: pro-beng…ca-vi-ti…pro-tei-shon. Or the Pantene shampoo bottle: for…dri…ja-ir. One of my cousins held the item for you to read, and everyone cracked up as she translated your broken English back to regular English for comparison. You requested a fresh twenty-dollar bill for every new item they brought to you, reading a slew of beauty products, body lotions, cleaning supplies, and beverages from the fridge.

But your bad English could also be enjoyed free of charge on a daily basis during your visits. A notorious lightweight—like me—you cannot stomach strong drinks. So when my cousins headed out to buy beers for the weekend barbecues you made sure to request the light American

beer you could handle—"Tráeme la Budasier!"—the one with the frog in the commercial. It was also a treat to take you out to eat and see you ask the waiters for the bathroom. "Ils batorrúm," you'd say as you approached them, and when they gave you a puzzled look, you reiterated it louder—"ILS BATORRÚM, PLIS! ¡No te hagas el sordo coño!"—and cursed them out when they failed to understand you.

In another language and when not directed at me, I find your anger amusing. English is a place where your words lose their teeth; their sting gets milder. Conversely, it's also a place where I'm able to articulate mine eloquently, my anger crystallizing in this lexicon that I know you can't access. From this new space, I can confront you without retaliation. In English, I can also tell you that I miss you and that I need my mom, because, in this foreign tongue, I know you won't be able to reject me.

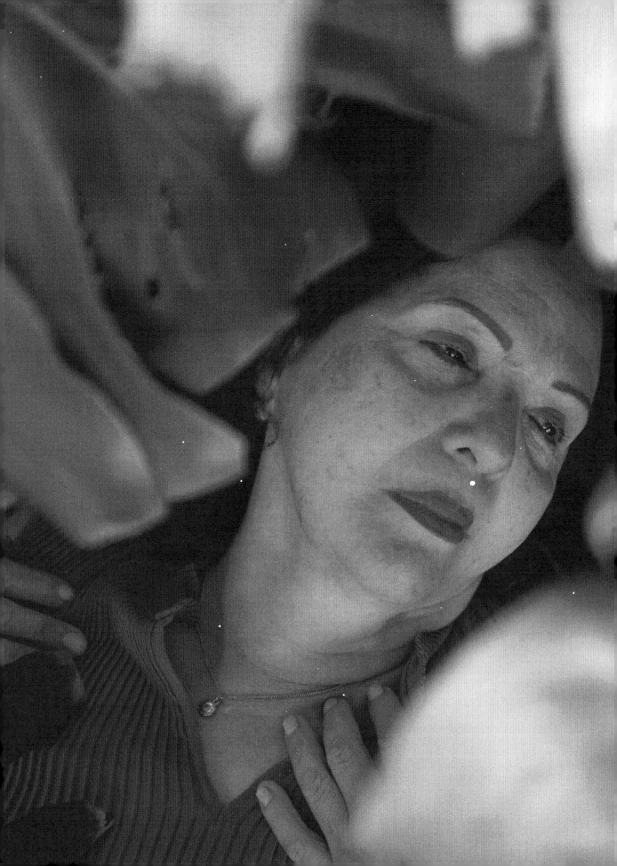

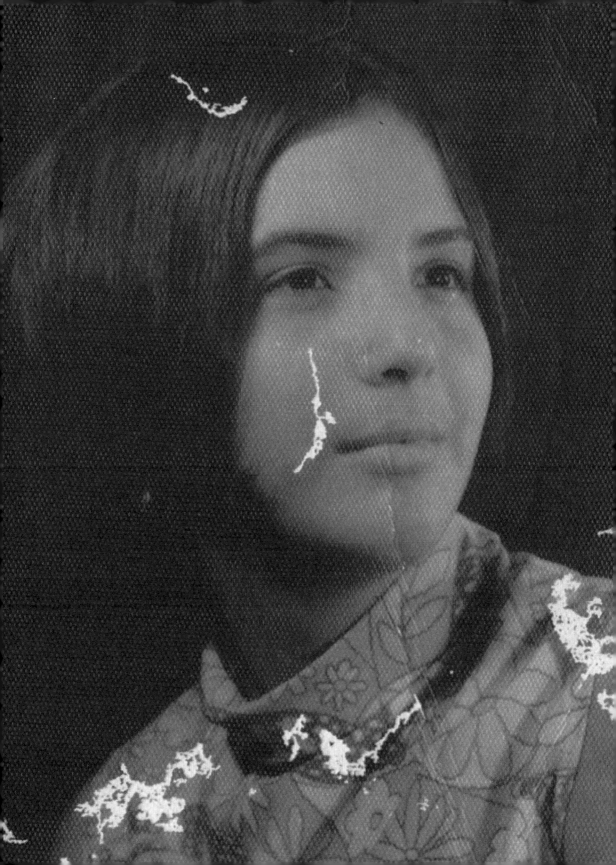

VESSEL

IN HIS BED, I shake him out of his sleep at midnight. "I'm pregnant," I tell him with absolute certainty. A sensation overtakes my body, a stillness in the pit of my stomach. All my insides coming to a halt as my body begins turning into a vessel. He is exhilarated, but the stillness inside me transfers to my face and I am unable to speak. We don't talk about my feelings about the pregnancy, but he informs me that we are calling his parents in Chile to give them the good news. The next day, we sit on his couch in front of the computer camera, and his mother begins pulling out different colored yarns she intends to turn into sweaters for the baby. My eyes sting. I start regretting having left my studio apartment in Spanish Harlem to move in with him. Your predictions unfold before me on this computer screen, your words still gripping my neck, even now, while living an entire sea away from you.

•

I DON'T SENSE THE DANGER when he reads me el capítulo siete de *Rayuela* out loud in bed to appease my sudden asthma attack. We are staying en la isla, in the wilderness of Samaná. Nature always makes me anxious. I tell him it's the most beautiful thing I have ever heard. He asks me if I've read Cortázar. I tell him I've never heard of him. He tells me that is what he likes best about me, that I am a diamond in the rough waiting to be polished.

•

I LIE ON A GURNEY in a busy hallway at Harlem Hospital. People pass me by for hours as I wait for a doctor to see me. Under the light-blue hospital gown, my skin aches from the cold, but the sterile fluorescent ceiling light has a numbing effect. They wheel me to a side room, apply cold gel to my stomach, and scan my insides to reveal an opening. On the dark screen, I see the thin gray outline of a circle, a nascent planet whose ring is already visible. I am five weeks. They wheel me to another room, this time one with a door and not a curtain partition. Two young male doctors are having a conversation about a car one of them is interested in purchasing. They don't ask me how I'm feeling, just request that I open my legs. Low mileage, leather seats, silver rims. They continue their conversation as one of them inserts a cold speculum inside me, its temperature the opposite of the warmness beginning to pool around my eyes. I skip my contemporary sociological theory class at The New School and take the train home instead. I draw the wine-red curtains in my bedroom and go to bed at 3 p.m. with my shoes still on.

⬤

UNDER THE CATEGORIES of anatomy and zoology, a vessel is described as a duct or canal holding or conveying blood or other fluid. Under botany, it is defined as any of the tubular structures in the vascular system of a plant, serving to conduct water and mineral nutrients from the root. Similar words are *channel*, *vein*, *trachea*, *artery*, and *passage*.

⬤

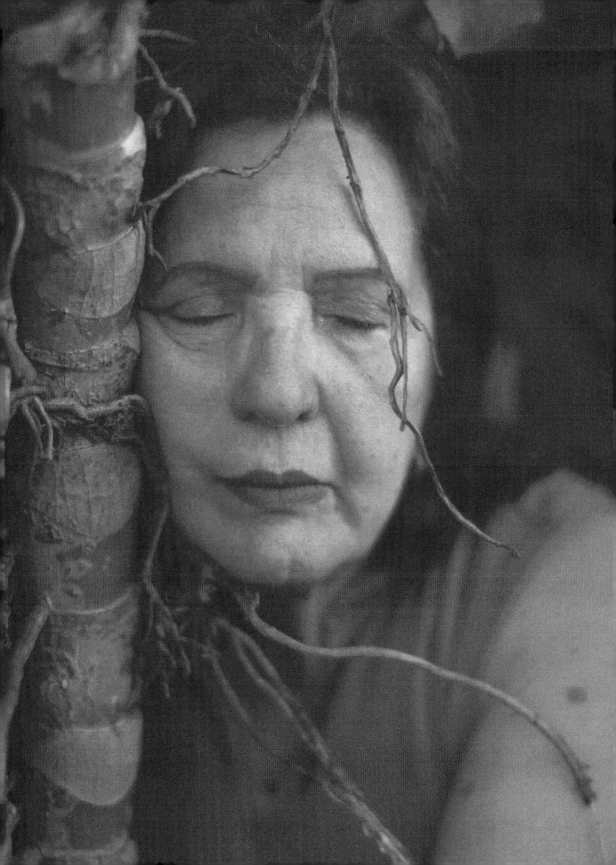

TÍA M INSTRUCTS my cousin M, her daughter, to put me on the first flight to Orlando, where she is now retired. I've stopped eating, and the clothes are looser on my body now than three months prior, when I found out I was pregnant. M tries her best to give me advice on what decision I should make after I call her while having a panic attack on the steps of Union Square Park. On Saturday mornings, I get a regular coffee at the bodega, take the 6 train from 103rd Street and Lexington Avenue, and get off at Union Square. I zigzag my way through the crowded farmer's market, past the fragrant stands with lavender pouches and ripe cheeses offered on a toothpick with a dollop of artisanal jam, until I get to the apple cider donuts. I buy two and wolf them down as I walk toward Greenwich Village, marveling at the prewar brick buildings and eclectic clothing styles, which I love but know I could never afford. It is these aimless walks by myself, more than the therapy sessions, that help me to process what happened between you and me, a slideshow of us playing in my head as the city roars past me. I find my place in a city where my tendency to withdraw is no longer a liability, where no one cares if I don't speak with you or if I am a bad daughter.

This Saturday morning, when I get off the train, I realize it's already spring and my thick black leggings will be uncomfortable to walk in. As I make my way toward the donuts, I also realize it will be hard to replicate these walks, my ritual, with a stroller and a baby. Four-by-six glossies of our home in Santiago begin flashing before my eyes, the usual slideshow of our moments together now flickering in unison with my breathing, but in these images, I am you and the emulsion over my face as a child has been smudged into an irregular white circle. I begin wheezing. A fear overtakes me that even if I never speak to you again, you'll come out in my actions when I become a mother.

The humid heat in Orlando slaps my face as I step out of the airport, but when I get to Tía M's house, the air conditioner is so cold I get

goosebumps on both my arms immediately. A shock wave of sensations slams my body out of its stupor, reminding me of the Korean spas I now like to visit, where I hop in and out of frigid and steaming pools as my pores constrict and expand. Eddie Santiago is playing on the radio and a pot of meat and vegetables is cooking on the stove, Tía's famous consommé she makes whenever someone in the family gets sick and needs replenishing. She greets me unceremoniously, as if I live next door and not in Nueva York, her way of diffusing a situation when it's getting out of hand. As the pot gurgles on the stove, Logan splashes in the kitchen sink filled with soapy water and cheap plastic toys.

Logan, rosy-cheeked and with wispy blond hair, is a one-year-old baby she takes care of for a modest fee while his mother works a nine-to-five. I want to retreat to the bedroom, to put the music and socializing on hold, but Tía asks me to drain the sink and dry Logan so she can stir the pot. I am feeling weak and fear I might drop him, but I manage to nestle my palms underneath his armpits and prop his arms over my shoulders as I dry his chubby legs and back. I lather him in pink Johnson's baby lotion, put the towel's hood over his head, and hand him off to Tía. I go to bed while it's still light out.

The days unfold like a choreographed dance, with me pushing to be alone and Tía pushing me to help her with Logan while she does chores. I bathe him, give him his bright orange baby food, and hand him over to her so she can take him for a nap and I can go back to bed. This becomes a routine. But today, as she tests the temperature of his milk on her hand, she gives me his bottle and asks if instead of going to bed by myself, I could put him down for his nap. I carry Logan up the plush beige-carpeted stairs, walking slowly so as not to disrupt the sleepiness overcoming him as he rubs his eyes. I shut the blinds in the bedroom and lay him on his side, dead center in the king-sized bed covered with a sage-green comforter. I give him his bottle and lie on my side facing

him. From a bird's-eye view, Logan and I two semicircles, constricting and expanding. We fall asleep until the sun goes down and it's time for dinner.

We come downstairs, groggy but restored. I am carrying Logan, and his head is resting on my shoulder, one tiny hand over my chest and the other one playing with my ponytail. I caress his warm leg over my stomach and notice for the first time the slight bump on my belly. Tía looks at me and tells me, "See? You can do this. ¿Tú no sabes que los muchachos nacen con el pan debajo del brazo?"

THE TUG OF SURGICAL SCISSORS cutting through my skin, the sting of cold water squirting from a peri bottle onto the minutes-fresh sutured wound, the stitches pulling the skin around my vagina when I cough. These are the sensations of the first hour of my motherhood.

The nurse asks me to get up from the hospital bed and stand on my still anesthetized, wobbly legs. It's been twenty minutes since I gave birth. She hands me the peri bottle filled with water and tells me to go to the toilet and wash the wound. I walk into the small bathroom adjacent to the hospital bed and get a glimpse of myself in the mirror over the sink. The blood I lost during the episiotomy has washed all the color from my face and what remains is a mask of pale yellow skin, framed by the hair around my forehead, stringy with sweat. I try to sit on the toilet but am unable to. My legs fail me. I tell the nurse I can't sit down, and she replies she is not asking me to do anything she hasn't asked all the other mothers in the ward to do after they give birth. I wash myself standing up.

As I get out of the bathroom, the nurse ushers me to a hard wheelchair, my pelvic area still throbbing and sore. She places Amaru in my arms. He is swaddled in a white hospital baby flannel with one stripe of aquamarine and fuchsia lines. His big eyes are closed, and his eyelids are shiny with antibiotic ointment. I ask the nurse wheeling us to the maternity ward why I can't stay a bit longer in bed and rest. She tells me another woman in labor is waiting for the bed. I realize I am not in a hospital but in the belly of a business; that the tender picture of two knitted yellow baby booties on the cover of the hospital's brochure was purely aesthetics; that my womb is just another line item in the US trillion-dollar hospital business.

Since it's past midnight, my cousin M and Amaru's father, who each held one of my legs as I pushed for hours, are forbidden to go upstairs to the maternity ward with me; it's past visiting hours. I beg the nurse

to let them stay with me, but she is a slab of cold steel. I get to the room that I'll share with another mother, separated from me by a curtain. The lights are out, and the only sound is the beeping of hospital machines and the faint cry of a baby in a nearby room. The nurse takes Amaru away from my arms and says he must spend the night in the newborn ward, hospital policy. I am lightheaded and don't recognize the situation I am in. I begin disintegrating in the dark room. In a flash of self-preservation, I realize something will split in my mind if I am left alone at this moment. I get up from the bed, the tube of the IV pulling at my arm, and start crying.

"Please. I don't want to be alone. I am scared. Let them stay with me. Please. Please," I say louder. The other mother behind the curtain starts tossing in her bedsheets. My face is salty with snot and tears, and when I look down, I am standing in a pool of bright red blood, dripping from a ruptured stitch, trailing down my legs to the white hospital floor. The second time in twenty-four hours my insides spill onto the floor.

•

AMARU IS FIVE DAYS OLD, and you come to Queens from la isla to meet him, your first grandchild. It's early December and we haven't seen each other since I moved to Nueva York three years back. You don't offer to stay and take care of me, instead staying only a couple of hours. You bring expensive linen pillowcases and burping cloths you embroidered yourself with his name, along with a teddy bear and a multicolored ball. As you take out your fancy gifts, I see you look around our basement apartment, and you don't have to open your mouth for me to know the list of things you find wrong with it. The cheap IKEA pine dining table and foldable chairs, the Haitian painting we bought at Calle el Conde in Santo Domingo of a group of women carrying baskets on their heads, the used yellow leather couch we found in the hallway in our last apartment

building and which I am now sitting on. I just breastfed Amaru before you arrived, and I am now burping him on my left shoulder while his father and you exchange disapproving stares in the living room.

"Tú no sabes cómo sacarle los gases. Tienes que darle duro," you say, yanking Amaru away from me. His small head wobbles as you pat him roughly on his back to burp him. I ask you to be gentle with him and hold his head, but you reply, "A los muchachos no se añoñan tanto. You don't know anything. You don't know what you're doing." For a brief second, I am Amaru, fragile in your arms, and you are one pat away from hitting me. I get up from the couch and take him forcibly from your arms, wrap him in his ivory fleece blanket, and place his tiny body on my chest, his head nestled in my cupped hand.

"He is my son, and I won't let you treat him like this," I tell you. My aching, sutured body is unable to stomach a second of your hardness.

When I see you walk up the stairs out of our apartment and into the street, the room I am standing in grows larger. The day after you leave, Tía M comes and stays with me for a week. She gets up several times during the night when Amaru cries, picks him up, and places him on my breast. She brings hot chocolate and steaming bowls of soup to bed, keeping me hydrated so I can produce milk. When he falls asleep after I nurse him, she encourages me to sleep as well, so she can haul bags of laundry through the snowy street to the laundromat a block away. She masks her sleep deprivation with her favorite caffeinated drink, a venti caramel macchiato from Starbucks—"Extra foam, extra caramel," she always instructs the barista. When I wake up from my nap, the floors smell of Pine-Sol, and Amaru's onesies are neatly folded on his changing table. She gives him his first bath in our bathroom sink. We watch the dried-up remnant of his umbilical cord fall off and give way to his belly button. I am not alone; the bittersweet feeling of being mothered by someone other than you.

In the following weeks, you call me sporadically to bicker with me. You tell me I'm a bad daughter because I love Tía M more than I love you. You tell me you'll only be in my life if I cut off communication with her. You tell me you won't attend my wedding if she is there. Every time I hang up the phone with you, I am crying. Amaru's father tells me I can't let you upset me like this; he brings up the idea of cutting off communication with you and I am relieved to be given permission to take a break from you. Although your words reignite the voice inside that always tells me I am not enough, I instinctively know I have to shelter Amaru from them, to create a deep enough chasm between you and me that won't allow your words to poison my motherhood. I give myself the opportunity to parent without your voice in my ear. We stop speaking for seven years.

●

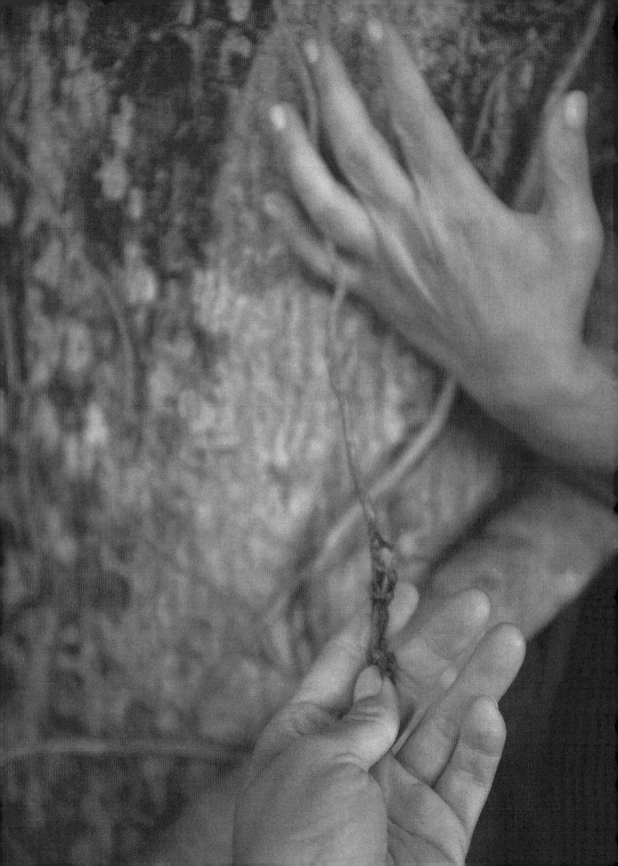

WHEN TÍA M LEAVES and Amaru's father goes to school, I am left alone with my son for the first time. He is bathed and wearing an outfit his grandmother in Chile knitted for him, lavender pants and a white sweater with pearlescent buttons and musical notes knitted the same color as the pants. The colored yarns that once frightened me on the computer screen now wrap your grandson's body. Observing my son for the first time, I recognize his father in him: big eyes, small chin, light skin. Taking one of his tiny hands and letting it grip my index finger, I see the long nail bed on his fingers, the same shape as yours, and mine. I lower my head to his crib and press my nose to his head. He smells brand new, baby powder and soft plastic. The same scent as my Nenuco doll in Santiago, freshly out of the package. I think how his name has the verb *amar* embedded in it, the azabache talisman traditionally placed on newborns' bracelets or in a safety pin on their clothing placed in his name instead. My fingers on the peach fuzz of his skin, my nose to the milky breath from his half-opened mouth. I pick him up, place him on my chest, and wrap both sides of my unbuttoned sweater over him. I give him everything I have yet to receive from you.

FOUR

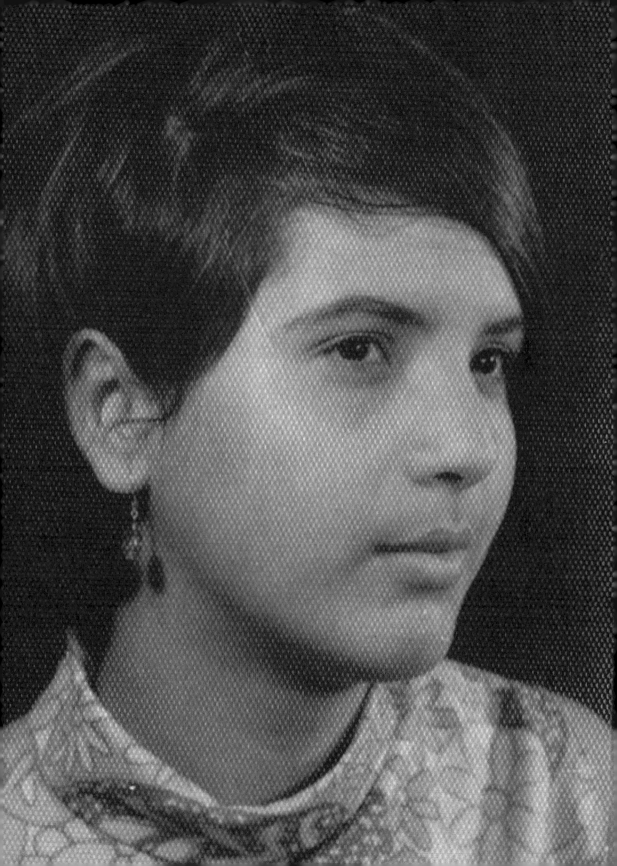

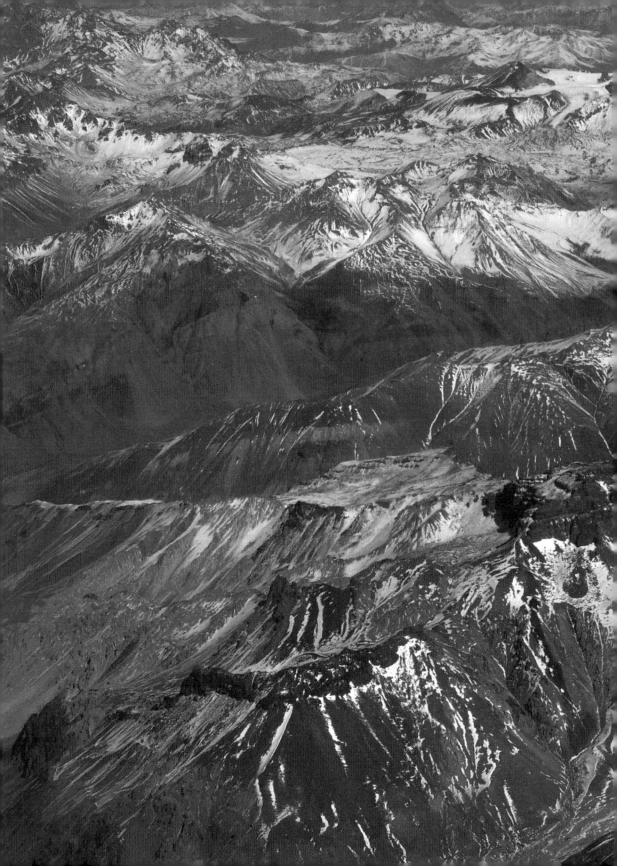

LUNGS

I WAS NOT THE ONLY ONE waking up in a sweat in the middle of the night. In the first days after our return from Chile, Amaru and I were sharing a small bed at my cousin M's house when he awoke in tears from a nightmare. In his dream, he was standing on a conveyor-belt-like floor, the kind they have at airports so you can walk faster to your terminal. He was standing still on the moving floor in the middle of Santiago de Chile, unable to move. As the floor moved below him, the buildings in the city started crumbling. One by one, they all dissolved to dust as he remained paralyzed. As everything fell, two birds flew toward his chest and removed something blue from inside it, flying away with it.

On the wall of my home studio in Jersey City, I keep a painting Amaru made in school during those months after our return. Black brushstrokes against ivory paper, dark dots in a swirling motion, like the trail left by someone bleeding. Behind all the black, lines of deep reds and greens leaving slight indentations on the paper, and in the center, an eye; an almond-shaped burst of blue.

●

AS WE DROVE UP the steep hills to Ancud, I started wheezing. It had been almost seven years since my last asthma attack, seven years since we last spoke. I was in the back seat looking out the window facing the Pacific Ocean while your grandson eavesdropped on his uncles sitting in the front. The windswept trees were bent into an unrecognizable letter. The altitude, cold air, and overpowering nature of Chiloé transported me to the verdant landscape outside the window of Papi's white Mitsubishi minibus on our way to Constanza, where he took us camping a few times a year. He had purchased the minibus to take us—his four children, our

cousins, and the neighbors' kids—to explore the island. For him, the extension of paradise outside the minibus windows was the cacophony of our laughter, banter, and unending questions as we discovered new parts of la isla. I don't recall being cold on these trips to Constanza, but I remember the warmth of my thick red sweatshirt with Bugs Bunny printed on it; the big multicolored pom-pom on my hat between my fingers as I fiddled with it while looking up at the ceiling of our camping tent, which at my young age looked like a cathedral; and the gallon of orange juice we left outside the tent overnight that turned to crystal shards when I shook it in the morning.

More forgotten images leak into my brain. The gold-painted iron fence of our home in Santiago, the way your lips wrinkled when you shushed me away, Papi's red polo shirt. The patches of an invisible quilt being woven back into existence in the back seat of this car. Papi was climbing a mountain like this one when he disappeared. As I climbed up to Ancud with Amaru, the thousands of miles I put between you and me, between my life growing up and the present, could no longer shelter me from the boulders pressing on my chest again.

●

WHERE IS sadness stored in the body?

●

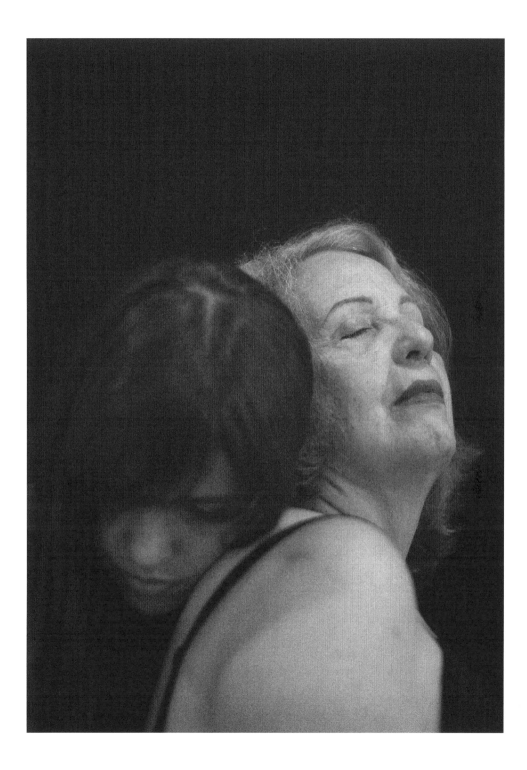

I FELT CHILE first on my skin.

Its dry desert air became perpetually evidenced in my chapped lips and in the tightness of my face.

Then I felt it in my bones.

Coming from overheated apartments in Nueva York, I was unaware that indoor heating was a privilege in South America, that the scalding, rusty radiators I was used to would have to be replaced by a combination of other objects to do their job. I arrived in Santiago de Chile in the middle of the austral winter. It took a few weeks for my bones and head to stop aching as my body got used to the cold indoors and we learned how to warm ourselves in our new home. Seeing myself wearing alpaca socks and placing hot water bottles under my bedsheets at night in the middle of July imbued this place with a certain mysticism. The purpose of Chile, I started to believe, was to turn my life upside down.

Lastly, I felt it in my chest.

My asthma started flaring up after years of latency. The Andes Mountains, bordering Santiago like a tall, snow-peaked fence, became a perpetual reminder of the places in my memory I had no access to, of a surfacing need to face the voids in my life. This new city was not the concrete aridness of Nueva York, intense and entertaining, its demands engineered to disconnect you from yourself. Here, you were locked inside. The geographic insularity of Chile, with the Andes and the Pacific Ocean encasing the skinny length of its two thousand seven hundred miles, translated into a skittish and reserved nature in its people, the direct opposite of our Caribbean temperament. This country at the end of the world, away from everyone I knew and where I was truly alone with your grandson, became in more ways than one, my third island.

●

I AGREED TO MOVE six thousand miles away when Amaru's father and his wife told me they had to move to Santiago de Chile for two years to fulfill a work commitment. The thought of my son—now seven years old—being without a father frightened me. In equal measure, the idea of uprooting my life excited me. When a friend of my cousin M, a judge in New York State, pulled me aside in a parking lot a few days before the move and asked me if it didn't scare me to make Amaru a dual citizen and move him to Chile, I dismissed her. And when a friend from my book club in Nueva York said my decision to uproot was selfish and would harm Amaru, I complained to our mutual friends about how much of a nosy bitch she was.

Tía M offered to travel with us and stay a week to help us move and settle in, so I was able to take advantage of her two allowed pieces of luggage. The small pencil lines on the white wall of our apartment in Queens documented the dozens of inches Amaru grew, indicating we moved there sometime in September 2011 and would be leaving in July 2014. It was in this one-bedroom apartment in Astoria that I started photographing our life, reversing with each image your systematic erasing of our family history. The black-and-white images I took of the apartment show a ray of sunlight on the small squares of the linoleum floor emulating real parquet; the brick wall outside our bedroom window, covered in vines that changed colors and thickness with the seasons; the wooden stool I placed against the kitchen counter so your grandson, still wearing diapers, could help me mix the bananas into the pancake batter, our Saturday ritual. As I stuffed the six bags with our most important belongings, I took a picture of Amaru sitting next to large boxes on the empty living room floor. The image depicts the half-opened boxes showing our books headed for storage and Amaru curled up into a ball,

refusing to part with the life we had built here, which I so willingly disposed of. In parting with things, in blank slates, in abrupt separations, a comforting familiarity.

●

I FOUND AN ELEMENTARY SCHOOL for Amaru in Santiago and a photography school for me in the port city of Valparaíso. For half of what we paid for rent in Nueva York, we could afford a sixth-floor, two-bedroom apartment overlooking large trees, right next to el Parque Forestal in Barrio Bellas Artes. The kitchen was galley style, long and narrow, with no windows, white tiles on the floor and walls, and white Formica cabinets. It also had a door that could be closed and locked, I guess in the case of needing to make meals in the utmost privacy. For the first time, Amaru and I had our own bedrooms, both with large windows and plenty of natural light. The cold temperature inside the apartment was overshadowed by the privilege of space and light, a luxury for renters in Nueva York. When we left Astoria, I could not dissuade Amaru from dragging his large beige IKEA plush dog, which he'd had since he was a baby. It sat next to him on the plane and then on his bed in his new room in Chile.

Unaccustomed to the chilly temperature indoors, Tía M caught a cold a couple of days after we arrived in Santiago. Despite being sick, she helped me organize my new closet with the few clothes I'd brought with me. She accompanied me to the city center to buy some cheap cups and plates as well as a square of metallic mesh at the hardware store to place on top of the stove burners, which were too wide to fit the greca I brought with me. We opened one of the three yellow packs of Bustelo coffee Tía packed in her suitcase and waited for the coffee to brew as we inspected the kitchen. We agreed that it lacked warmth and that the pervasive whiteness and the fluorescent ceiling light made it look like a hospital.

We sat on the red futon couch the furnished apartment came with and shared our first cup of coffee in Chile, tar black and really sweet, like Tía M drinks it. This was also where I made my first photograph in this apartment, a black-and-white photo of Tía spooning Amaru on the futon as they watched cartoons, a large potted plant to their left and a self-portrait of Frida Kahlo above them on the wall. The second photograph I took was in the moments before she left for the airport, an image of a few crisp Chilean bills and coins she placed neatly on top of Amaru's bed with a note on a paper napkin: *Amaru, recuerda que me prometiste portarte bien. Te amo mucho, mil besos mi niño amado. Nena.*

At the airport, when I hugged her goodbye and started sobbing, she brushed my crying off, gave me a quick hug, and said, "No llores, mi hija. ¡Todo va a estar bien!" When she rushed through the security gate without looking back, I knew she was about to cry, and she knew that at that moment, more than sharing our fears, I needed her reassurance. That sharp motherly instinct that can discern when a single tear can make everything fall apart.

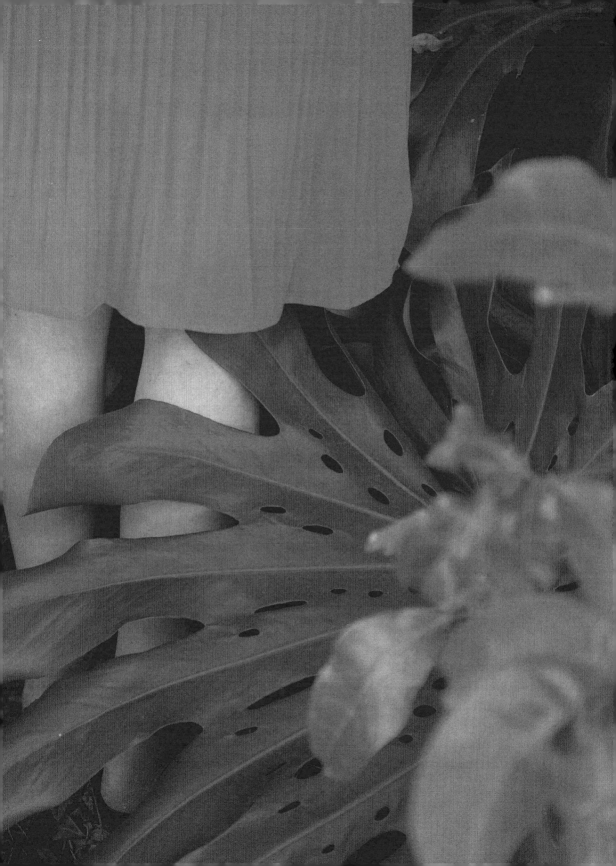

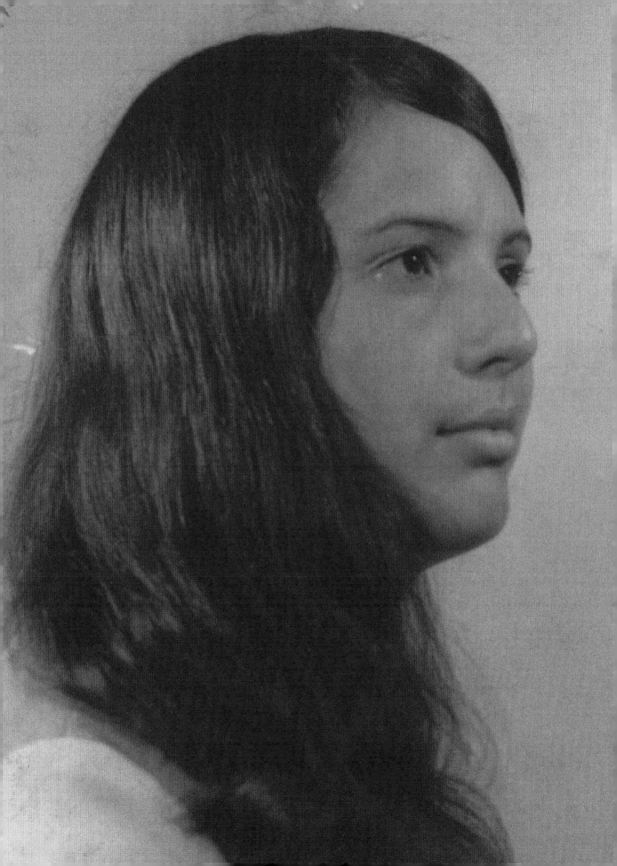

DARKROOM

I AM SITTING INSIDE a federal courtroom in downtown Manhattan, its wooden interior a pristine prison squeezing the air out of my chest. Amaru's father, the plaintiff, is sitting on the bench next to me, the back of his gray suit inflating every time he takes a breath with a calmness that further infuriates my pounding heart. The judge, I learned after Googling him, has presided over high-profile cases, including the Abu Ghraib case and lawsuits arising from 9/11 related to wrongful death, property damage, and personal injury. Face to face with the person who brought justice to these harrowing events that shaped American history, I feel minuscule, and the predicament of my life, frivolous. It's the third day of the trial and my teeth and jaw hurt from clenching. When I allow myself to relax, a rush of cold washes over me and I feel like I'm going to faint, so I resume my clenching. The day is coming to a close and tomorrow will be my turn to be cross-examined. The judge, who thus far has avoided looking at Amaru's father and me in the face, turns his gaze toward me and lowers his head so his eyes meet mine without the barrier of his thick, round glasses. He holds my stare and I understand he is instructing me, the person who committed the crime, to settle the case when he says, "Let me be clear: I will side with the law."

●

IN CHILE, YOUNG CHILDREN wear a robe called a *cotona* over their uniform when they go to school as a way of keeping their uniform clean. On his first day of school, Amaru looked sharp in his white polo shirt, navy-blue pants, and black leather shoes. I'd bought a bike with a back seat for him and we rode uphill for forty minutes to his new school in Barrio Providencia, his ironed beige cotona trailing behind us like a cape. I was

sweaty and my calves ached when we arrived at the school, but Amaru's excitement and eagerness to scurry off as I wished him a good first day overshadowed my physical strain. I rode back along the chocolatey waters of the Mapocho River and the bike glided in the cool morning breeze as I took stock of historic buildings, storefronts, street vendors, stray dogs, and species of mature trees lining the road, all foreign to me. You and me now so far apart that you became a distant memory. The fading bodily scent of a used blouse tucked away in a suitcase. The small circular scar of a closed piercing on an earlobe.

A sweet brief high, a spike of serotonin, a tinge of electricity under the skin. Topography as a drug.

This was the feeling I was chasing by moving there, the freedom of disposing of my narratives, the lightness that overcame me in the face of the unknown.

I was still elated when I picked up Amaru at school in the early afternoon. The effusiveness I was hoping would meet mine was absent in his face. He refused to talk when I asked him how his first day was, but I got my answer when, at home, I removed his dirty and wrinkled cotona, prepared a hot bath for him, and felt the glob of gum in his hair, melting in my hands under the hot water. I was surprised to notice that I felt angry not at the situation but at your grandson, submerged in the warm, soapy water. I should have hugged him and told him I loved him and that I would be there when he was ready to talk. Instead, I left him alone in the bathtub and told him to not make a mess on his way out.

·

AMARU WOULD STAY with his father in Barrio Las Condes when I traveled two nights a week to Valparaíso for my photography classes. The fixation on hoarding our family photographs that I had developed throughout the years naturally progressed to me wanting to make my own. The photography school was called Cámara Lúcida, a nod to the history of photography and the famous text by Roland Barthes. The school was located in a historic house in Cerro Concepción, one of the hills in Valparaíso. Its interior was all pristine wood, with brick walls and vaulted ceilings leading to a skylight. Toward the back of the house was a doorway closed by a thick black curtain that led to the darkroom where our work would take place.

Our teacher, Caro, was a soft-spoken petite woman with salt-and-pepper hair and olive skin who always wore knitted sweaters, blue jeans, and boots. She turned the red light bulb on. A large table appeared in the center of the darkroom, wires above it clipped with wooden clothespins. To the left was a long counter with half a dozen enlargers and to the right a large metal sink, with a shelf holding plastic trays and developing liquids. Opposite the counter with the enlargers was a wooden door with a round metal lid covering a small opening leading to the street. Every surface was bathed with a crimson hue before Caro turned the light off. She took a sheet of photographic paper and taped it to a post a couple of meters away from the door. She lifted the lid off the lens in the door opening and an inverted image of the street outside projected onto the paper. The outside world moved inside for a few minutes as the six of us, all women, stood in silence inside the camera obscura. Caro covered the opening, turned the red light bulb on, grabbed the paper with plastic tongs, and bathed it in the developing solution. As she shook the tray submerged in the water, we began to see the old building across the street, a lamppost with a hive of electricity cables, the cobblestone street, and the tiny grasses sprouting from the cracks in the sidewalk. Inside

me, another alchemy took place. In photography, I started to find the ability to connect with another part of me. A second woman emerged, someone who was not a nuisance, someone useful and talented.

A bifurcation.

Like that photograph from Sergio Larraín that I always loved so much of two girls crossing a passage in the hills of Valparaíso. They're both wearing similar dresses and have identical haircuts, yet the girl in the foreground is younger and obscured by a shadow, holding a crystal bottle, while the other one, older and fully lit by the sun, descends into a staircase. The older one advances, yet it is the little girl who holds the potion in her hand.

●

WHEN THE BULLYING progressed to Amaru being ridiculed for his mouth breathing, getting choked by his classmates during recess, and being teased by the school staff because of his gringo accent, we knew it was time to switch him to another school. The public school system in Chile, I learned the hard way, was very different from the one in Nueva York. The new school we switched him to, private and in a more affluent part of Santiago, meant the teacher-to-student ratio was smaller, and the better-paid teachers more invested. Under this individualized attention, your grandson's issues came into focus. During his first week there, inside his backpack, I found an illustrated story he wrote of a rabbit who could not find a place to hide his carrots. He hopped from place to place, but the soil was hard and impenetrable and he could not store his food. Next to the handwritten story, colored in orange and green Crayola, he drew a stack of carrots scattered at the bottom of the page.

As he learned to express his feelings on paper, I honed mine in the darkroom. When the images appeared on the paper underwater, I began to understand how I think, what kind of light and gestures move me, what is the core of my sensibility. These early black-and-white prints display a budding interest in self-portraits, in street photography, but they also show Amaru looking progressively morose and withdrawn, which felt like a confirmation that moving there had been a bad decision. His sadness, a direct accusation against my motherhood.

●

IT'S A SATURDAY MORNING and I snake my way through the bustling Mercado Persa Bío Bío in Barrio Franklin, the largest market in Santiago. A friend told me they sell used enlargers in this market, and I want to purchase one to turn my galley kitchen into a darkroom. I walk the long corridors lined with dusty upholstered chairs and tables displaying china and crystal vases like the ones you filled our home with.

I think of you.

Farther down is a wall strewn with chandeliers, bronze sculptures of cherubs on the floor, antique clocks, and bucolic paintings of what looks like the European countryside. I see an ornate ceramic Italian vase with intricate flowers and, embossed on it, a Renaissance couple kissing.

I think of Tía D.

Tía M would hate it here because she likes new things. Out of her sisters, she is the only one whose house has modern blinds on the windows instead of custom-made cenefas in brocade fabrics, the only one who prefers American-style leather couches in lieu of oak furniture.

I find a table with dozens of beat-up cameras: used Yashicas, Minoltas, and a few older models of digital Canons and Nikons. I ask the middle-aged man if he has any enlargers and he tells me no one uses them anymore, so he doesn't sell them at the market. But he says he has one at his house that he can sell to me. I am unafraid when I walk with him ten blocks in a deserted, sketchy stretch of the neighborhood, and when I enter his house and then a dark bedroom where he pulls a box out of a closet. The Vivitar enlarger from the 1970s is in good shape, he tells me, but needs a light bulb and some black tape to cover the light leaks in the bulbous lamp house at the top. It cost me twenty-five thousand Chilean pesos, about thirty US dollars. On the train on my way home to Barrio Bellas Artes, I place the enlarger on my lap like a child and hold its shaking round lamp house when the train rattles. I hold it tight, afraid any sudden movement will damage it.

I think of Amaru, and my inability to care for him this way when he is hurting.

In my kitchen darkroom, with the red light on and the door shut, I go into myself and physically separate from your grandson. This windowless space, a makeshift barrier sheltering me from his sadness. The basics of developing become apparent: the more something is exposed to the

light, the darker the image. At this juncture of my life, when I am finally rediscovering my joy, Amaru's depression has forced me to look at mine. I've become impatient with him. When he starts having nightmares and knocks on my door in the middle of the night, I get up to ask him what is the matter and then tell him to go back to his bed. I tell him it's not okay for him to sleep in my bed with me and that I don't want him to become a mama's boy. He is crying and clings to my pajamas and I feel like yanking him off me, like giving him un par de nalgadas para que no sea tan ñoño. I close the door on him and go back to bed. Under my sheets, I cry out of frustration because I see clearly that he is me and I am you. I am unable to comfort him as we both hurt in different bedrooms of this apartment. I hear his shy footsteps approaching my closed bedroom door again and see a white piece of paper slipped under my door, a note in his little-boy penmanship: *¿Estás llorando?*

Only in hindsight do I see this episode as one of the many instances where Amaru would swallow his feelings to prioritize mine, as the origin of his reserved and sometimes withdrawn nature. It was also the first time I realized it would take work—more than space and distance from you—to learn to mother him when he reminded me of myself.

That week, I make a self-portrait with your grandson. He is playing in my bedroom and gets behind a floor mirror in my room. I stand in front of him and see only his head and his hands behind the mirror as he holds it, and in the mirror's reflection, my trunk and legs. We are one, a mythological creature half child, half adult; the painful illustration of our role reversal. I press the shutter.

●

THE SUN FALLS SILVERY and bright on Valparaíso Bay, which can be seen from the balcony of Caro's house, where my walk starts. I take a picture with a white window rail in the foreground, the midday sun a mound of sparkles over the water in the horizon. The hills are dotted with colorful houses, their windows draped with plants and clothes drying in the salty air. Looking down from the balcony, I'm suspended above the Spanish patio of an old house, where an ivory-colored dog is napping on the warm red-and-white tiles under the sun. From up there, I can see people going up and down Calle Yerbas Buenas, with plump bags I imagine filled with sweet strawberries and freshly baked hallullas, the kind they sell in Bellavista at the foot of the hill.

In the hills of Valparaíso, the silence is immediate. So lovely that I can ignore the fermented drunkard's urine in the corner of the passage and the dog feces, so ubiquitous they seem to be emanating from the pavement. I clean my shoe and the stench feels irrelevant because profound things are not easily ruined. In a matter of minutes during my walk, everything becomes simple and I only notice the colors. The graffitied walls in Calle Urriola, the pastel-colored houses in Calle Templeman, the blue facade of Hostal Casa Azul in Calle Pasteur, where I stay a couple of nights a week while I take my photography classes. On my first night there, I met Ana while she smoked a joint with a German girl backpacking her way down to Ushuaia. I approached the communal dining table with a falafel I bought at the foot of the hill. They invited me to a glass of cheap red wine, and as the night fell, they shared their joint too. In her fifties, Ana was the oldest. I don't remember our conversation but retain the vivid image of a piece of blue felt with green fibers in its center that Ana had made by hand. She showed us her felt and how she arranged the different colored fibers before securing them in place with the hot iron. She also told us about leaving her life in Santiago to travel around the country, to find herself now that her children

had become adults. I looked at her felt and it touched me. It seemed like a permission slip she extended to me, a complete stranger, giving me the right to change my life as I pleased.

·

SOLEDAD, THE THERAPIST Amaru's school recommended, asks Amaru and me to sit on the floor while she observes us from her chair, notepad in hand. From the floor-to-ceiling windows of her fourth-floor office in Barrio El Golf, I have a view of the street below. Looking out the window, I mentally cross the street several times during the one-hour session, join the pedestrians below, and run to the closest metro. She hands us mounds of Play-Doh and asks us to each make an animal to represent ourselves. I look at the mounds of colored molding clays for several minutes as I mutter to myself that this is utter bullshit. Amaru is way ahead, making the long neck of his animal, when I roll a strip of clay, slightly longer than a hand-rolled cigarette. It takes me fifteen seconds and I am done.

"What are your animals?" Soledad asks.

"A dinosaur," says your grandson as he holds up his Brachiosaurus.

"A snake," I say, looking at my amorphous strip of clay.

"Interesting," says Soledad. "I think it looks more like a worm. It must be difficult to feel like one."

I look at Amaru, and his giddiness at this stupid play therapy infuriates me.

In another session, when Soledad tells Amaru's father and me that your grandson should take medication to help him with his ADHD and depression, I refuse. I tell her that medications are a cop-out by a faulty school system and that his mood is just temporary, due to his transition into a new country, a new school, and new friends. Amaru's father tells

me to consider the stigma surrounding people who have to take medication for mental health issues. He adds that my religious baggage from la isla is making me feel guilty about medicating him. I tell him to fuck off.

At the end of the session, Soledad tells me in front of Amaru's father that I should go to therapy. "I know an excellent psychologist. Her name is Coni."

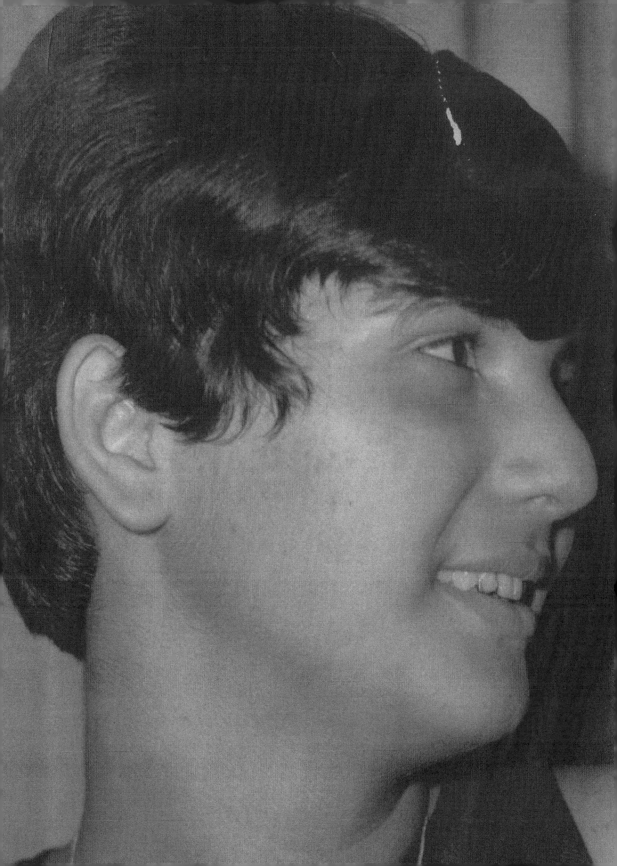

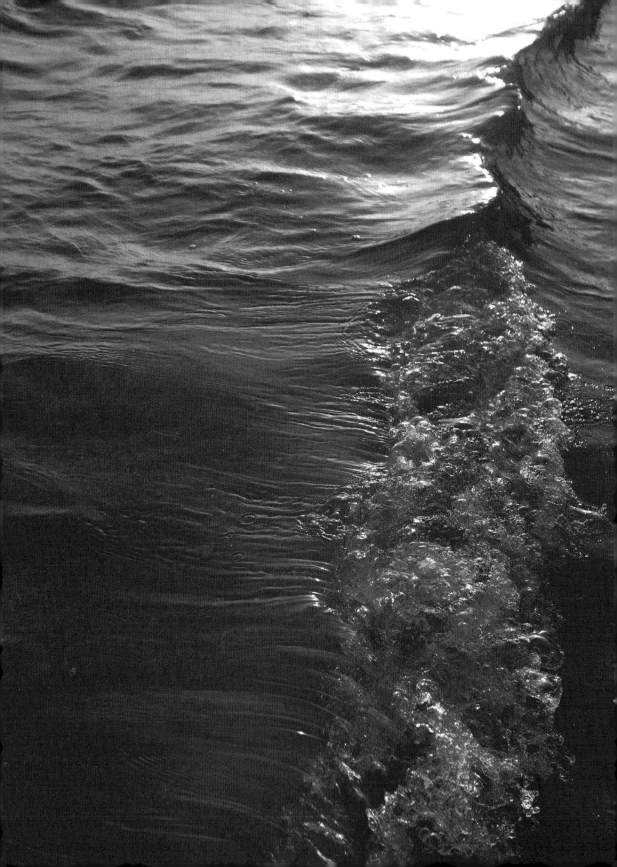

BACK TO THE WOMB

WE DROVE TWO HOURS south of Santiago until we reached a town called Callejones. A Chilean friend who liked my photographs had asked if I would document an indigenous spiritual gathering called Raíces de la Tierra taking place there. I agreed and also volunteered to accompany the organizers to prepare the land, specifically to get the kiva in shape for the upcoming ceremonies. They were a tight-knit group of artists, holistic healers, and a few photographers, some of whom were in their seventies and had been part of documenting the resistance during the Pinochet dictatorship. Getting to know this group of people, I intuited, would enrich me spiritually and artistically.

Half of us went up to the mountains to gather rocks—which would later be fired piping red for the temazcal—while the rest of us started preparing the kiva, a circular opening in the ground for spiritual leaders to pray from inside la madre tierra. A small inroad was carved in the red soil to enter the underground circumference. It looked like those emptied-out pools kids use for skateboarding. Like an oversized version of the holes people in Chiloé dig in the earth to bury their pots when making curanto. We transported piles of hay and buckets of wet mud down to the center of the hole to plaster its walls. It took me several tries to learn the right consistency of the mixture, compact in my hands like a raw hamburger patty.

We took cigarette breaks from making the mud walls and sat under the shade of a large tree. Everyone rolled cigarettes of natural tobacco. I find natural tobacco too strong but didn't want to be rude, so I smoked them. Sitting next to me was a slender woman with brown hair down to her waist who talked about growing her own food and feeding her body well in her fifties, a tinge of arrogance in her voice. A man reminisced about a

time they went camping on top of a mountain and prayed together until sunrise. I spaced out as their anecdotes got richer with the intimacy of friendship. They passed around a large thermos with mate and I drank it even though I hated the bitter taste. I looked down at my hands to pass the time. The caked mud on my fingers resembled the cracked red desert soil below me. I asked myself, "Why am I here with these strangers and not in Nueva York with my real friends? Why am I honoring these traditions so foreign to my culture? Why am I making this pit in the middle of nowhere?"

—

FROM THE COUCH, we start to go back in time. Coni asks me to lie down while she puts a few drops of rose oil in the diffuser. The room becomes hazy with the floral mist, a smell that reminds me of the cheap perfumes and creams you sometimes send me from Miami. A smell-to-memory connection I can only piece together in hindsight because at that precise moment, we haven't spoken in years.

Coni asks me to remember one of the countless grudges I hold against you, and I tell her it's the beating with the hanger. The bruises on my arms that I had to cover with a long-sleeved striped sweater to go to school the next day. No one at my middle school understood the need for a sweater in the Caribbean heat of Santo Domingo. She asks me to close my eyes and describe the hanger. I tell her it's made of hard metal, the kind they give you at the dry cleaners in Nueva York.

"Now you're going to take some pieces of foam and wrap the hanger," she instructs me. "Wrap it until you can't see the metal anymore, until its corners become soft."

I wrap and inhale the roses. I wrap until the hanger is fat and unrecognizable, until it mutates into a cushion that I can sit on.

—

WHEN I FILED THE SUIT in la corte de familia, my request was simple: your grandson and I were both American citizens and wanted to return home to the United States. But my petition turned more complicated when Amaru's father, who had adamantly refused to let us return earlier than the two years agreed upon, filed a countersuit requesting full custody of your grandson. Some of the phrases used to describe me that my lawyer highlighted in his countersuit were "unmarried," "unfit parent," "a person with a fragmented family who doesn't even speak to her mother," "someone with no support network in Chile." My blood boiled at his betrayal; at him taking my parenting struggles out of context to paint me as a bad mother; at his ungratefulness after I made such a big move to accommodate his plans.

My anger toward him gave way to anger toward myself. Six years after we separated, he still had enormous control over me and I had been the one to allow it. Worse, it seemed that I needed it. On numerous occasions, my friends in Nueva York had asked why he moved across the street when we separated and insisted on picking Amaru up every other day, not allowing me a stretch of uninterrupted time with my son; why he tried to force me to not vaccinate our child, engaging me in a months-long battle; why he always managed to cut my time with my friends short, insisting I leave everything to go pick up your grandson when and where he decided, so specific in his instructions as to dictate which car I should be standing in front of when they got off the subway. His tight grip felt soothing, I now understand. In our enmeshed dynamic, a tangible attachment, something that in our mother–daughter relationship had long been broken.

Inside the courtroom, I see the judge assigned to the case. She is an older woman in her late seventies, with droopy eyes, dark hair, and a face full of heavy, cakey makeup. For a brief second, her bright red lips

painted outside the natural contour of her mouth make me think I am in a theater play and that this is not my life. This is probably a tragicomedy, where a female judge, hungover and incoherent, decides the fate of a mother and her child. The play takes place in an extremely conservative country where abortions are banned and foreigners ostracized. In this play, the mother interprets both the plaintiff and the defendant. Every time she opens her mouth, the audience points and laughs at her.

Spotlight on.

The father steps onstage, wearing a navy-blue suit, an ironed white shirt, and a dark tie. He is a white, highly educated Chilean man, married, with a steady job as a researcher. He has a large family living in Chile. His mother is one of seven siblings, which means dozens of aunts, uncles, cousins, and other kids the son's age.

The mother steps on, fully naked. Her breasts are sagging and stretch marks line her stomach, evidence of the child they are now trying to take away from her. She is a single woman of darker skin than the father. She is a foreigner from the Caribbean, where some women emigrate from for prostitution in Chile. She is fatherless and motherless. She has no relatives in Chile and only a part-time remote job. In this play, which we'll call *Back to the Womb*, the mother stands no chance.

◍

183

ANA AND I BECAME close during my time in Chile. We took long walks in Santiago, she showing me not the main landmarks but her favorite centenary trees, gifting me a more delicate way of valuing my surroundings. We often stayed together in hostels in Valparaíso, wandering the hills and then making our way down for seafood empanadas at the beach in Caleta Portales. Like me, Ana had a pulsating yearning to uproot, to escape situations when they became too familiar, eager to know what dormant aspects of herself would surface in the new place. Unlike me, Ana sought the quietness of nature, often exchanging chaotic Santiago for the countryside. She would retreat for weeks at a time, and when she came back, she would have spun dozens of spools of wool yarn. In remote areas of Chile, she learned to shear goats; take mounds of dirty wool and pluck out any pieces of hay, burr, or manure; and then boil it in large pots of water and soap. It might take a few days for the wool to dry outside, depending on weather conditions. "People only see the fun part, when you are sitting in the spinner and twisting the white threads into a neat roll of yarn," she told me. "But they don't know that only with time and patience can the wet and heavy wool be cleansed and become light again."

When I visited Ana at her home in Ñuñoa, she would show me her notebook of dye experiments. Its pages were shaded with subtle greens, browns, yellows, and reds from plants she used as natural dyes for her wool, extracting them from onion skins, avocado pits, and green leaves. She would also unravel small rolls of ivory fabric to show me the humid plants and flowers she was pressing against the fabric, creating delicate botanical prints. By sharing her experiments with me, Ana became my teacher—her presence a rich compendium of how to interact with and document the world around me—my very own Chilean Anna Atkins.

During her travels, more indispensable than a backpack was her loom, which she'd lay out in the wilderness to weave cloth and tapestries

inspired by the nature surrounding her. From one of her lengthy retreats in San Juan de Pirque, near Cajón del Maipo, I keep a poncho she made me, with threads of wool in bright greens and rich browns woven with a few thicker pink strands, reflecting the verdant landscape dotted with blossoming peumo trees. A wearable photograph of the Chilean spring.

A sense of relief came over me when Ana said she would accompany me to Raíces de la Tierra for the celebration. I could share this spiritual experience with a real friend instead of being the stranger stringing along. We shared a camping tent in a vast expanse of flat land in Callejones, talking late into the night, her sharing wisdom from Ram Dass, whom she was studying then. At 4 a.m., we unzipped the tent to reveal a starred, inky-blue sky. We washed our faces in the communal bathroom and headed to a massive bonfire with hundreds of people praying around its circumference. I shot the first images at the crack of dawn, of people midprayer with their eyes closed, surrounded by speckles of bright red fire against the muted orange sky.

It's now early morning, the sun is up, and the bonfire is a dark, smoky circle on the ground next to the flattened round temazcal tent. Next to this tent, a smaller bonfire is crackling where some people drop barrels full of rocks to be fired crimson. A photo frame of this scene is a conglomeration of circles extending from the ground to the horizon.

The temazcal tent is built with a series of wooden spears bent to form a makeshift ceiling over which a heavy tarp is laid, making a flat hut, its shape similar to an inflated pita bread on the heat of the griddle. It's the same circumference as the kiva but above the ground. The tent is so low, it's impossible to stand inside. You must sit or kneel, anchoring yourself. At its center is another hole, where the scalding rocks are placed before the ritual begins. Its origin dating back to ancient civilizations throughout Central and North America, including the Maya, Aztecs, and Toltecs, the purpose of the ritual is to purify the body and mind.

Before entering the tent, an intention is set, and participants must recite it as they go into the circumference. For my first temazcal that morning, I recite the intention given by the shaman, "Por mí y mis relaciones."

A chanting erupts in a language I can't decipher as I kneel in the packed tent. I shouldn't have worn a dress, because twigs and small pebbles on the ground are pressing into my knees. Unable to understand or sing the ancient chant, I feel like an imposter. A woman with long dark hair in a braid with a feather dangling from it drops a bucket of water onto the hot rocks in the hole. The tent fills with heavy, scalding steam, and beads of sweat collect on my skin instantly. My eyes sting so I close them. The soil below me moistens, pasting me to the ground. I take a gulp of air and the steam fills my lungs with heat hotter than the surge of steam released from a pressure cooker when you loosen the knob on the top. More potent than ten pumps back to back of my albuterol sulfate medication. A geyser in my chest. I run out of the tent and fall to the ground lightheaded, coughing. I am unable to withstand the ritual for the sake of our failed relationship.

I make images of the kiva ceremonies; of people hugging after they come out of the temazcales, their wet skin still steaming and their hair dripping sweat; of the various religious leaders with their traditional garments featuring wooden beads, intricate necklaces in precious metals, and headpieces with exotic bird feathers. In my free time, Ana and I attend spiritual talks in the shade of large trees and volunteer in the kitchen, chopping baskets full of cabbage and shredding carrots for communal meals. As we peel and chop vegetables, she encourages me to give the temazcal another chance.

On our last night there, I attend the evening temazcal by myself. The intention of the ritual is "Por el hogar y las raíces." I recite the mantra and step into the tent. This time, the ritual is so packed that people

cannot sit cross-legged but must kneel facing the back of another person, forming a cluster of bodies organized like a domino chain, each person less than ten inches apart. My chest contracts in anticipation of the scalding steam, and looking around, I see it would be impossible to storm out mid-ceremony without trampling those around me. This time, the shaman speaks in Spanish, encouraging us to close our eyes and take quick, shallow breaths as we think of where we come from, our ancestors, and the land we were born in. The collective quick breaths make a distinct sound, a kind of guttural chant. The sound of a woman in labor at the height of her contractions. The first bucket of water is thrown over the scorching rocks, and because of my shallow breathing, I am able to withstand the steam. With each short breath, I think of my family and my friends back home, of the moments we shared in my small apartment in Astoria, when in community, they helped me raise Amaru from a baby to a happy young boy. I envision Tía M, Tía D, and my cousin M, todas mis madres putativas that held me up and carried me into adulthood. The steam around me brings to mind the steam coming out of manholes in the streets of Nueva York, blowing from giant white-and-orange tubes. I miss my city and its putrid city smells. My shitty apartments. My sugary breakfast cereals and my saccharine bodega coffee on my daily walk to work. At this juncture of the ritual, the shaman asks us to forgive, to let go of what our land and ancestors have passed on to us. I realize that when I think of home, I see Nueva York and not la isla, that those roots from the first years of my life are long severed. I mourn Abuela, I mourn Papi, I mourn my motherland. My sweat and tears become the same body fluid. I crouch down farther, bending into a fetal position. My forehead touches the sweaty naked back of a man in front of me. When he doesn't complain, I allow my head to rest on his back as I cry, his breathing cradling me.

"Mami, te quiero. Te extraño," I call to you from inside the womb, allowing myself a second to feel what I've learned to bury so well. I inhale the hot air in small spurts, my lungs ablaze.

When I step out of the tent and into the cool summer night air, Callejones is blanketed with a starry sky, the stars clear as can only be experienced in the driest places on earth. My clothes and hair are drenched. I see Ana waiting for me with a steaming cup of tea. She opens her arms and embraces me as I begin to cry again. In my ear, she mutters, "Mi niña."

On our way back to Santiago driving on la Carretera Panamericana Sur, we make a pit stop at a rest station; it's filled with American fast-food chains, including Starbucks. As everyone goes to the bathroom, I hold my pee, head straight to Starbucks, and ask the barista for a coffee, a venti caramel macchiato, extra foam, extra caramel. Just how Tía M likes it.

●

AFTER RAÍCES DE LA TIERRA, I come back home to Santiago to an empty apartment. I am still in a trance after the temazcal. I drop my dusty bags in the living room and head straight to Amaru's room.

I scan it from right to left.

His small navy-blue slippers with the white furry interior placed next to his nightstand.

The IKEA plush dog on top of his bed.

A few unfinished LEGO creations on his play table.

His red pencil case on his desk. I open it, and among the colored pencils, I find a small doll dressed in bright indigenous clothing. I inspect it for several minutes: the blue cloth over its head; the fuchsia shirt and multicolored Mayan skirt; the mouth and half-closed eyes stitched on with thin thread; the wide-open stick arms. Two inches long, flat on its back at the center of my palm, it looks like a tiny person doing snow angels or about to fall asleep.

When Amaru comes home a few hours later, I hug him and tell him I've missed him these few days I've been away. I show him the doll and ask if a friend gave it to him. "Soledad gave it to me," he says, taking the doll from my hand and placing it back in his pencil case, protectively.

"Why did Soledad give you this doll?" I ask him, puzzled by her gift.

"Es una muñequita quitapenas. She said that when I feel worried or sad, I can tell the doll my worries and it will take care of them."

A sharp pain in my chest. A fist in the pit of my stomach. Instead of retreating, I kneel and pull Amaru close to me. I hold him so tight I can feel his heartbeat on my chest and the scent of shampoo in his hair. I can't talk, but what I want to say to him is that I am so sorry. That it makes me sad to see this tiny amulet of sticks, wires, and fabric has been protecting him better than I have.

That whole week, Amaru slept in my bed, our bodies two semicircles stacked against each other. On our way to his school in the mornings, the

long bus swerved like a snake as I held his head tight against my stomach and he circled his small arms around my waist. When we managed to get a seat, he'd fall asleep again and I'd study the lines of my bedsheets marking his face. A map of our journey together in Chile that only I could read.

That weekend, Amaru and I traveled to Valparaíso for my thirty-second birthday. We took el funicular up to Sutherland House, a restored 1870s guesthouse nestled in the hill of Cerro Alegre. Our room had large wooden windows and a balcony overlooking Valparaíso Bay. We dropped our bags in the room and set out to explore.

The photographs I shot that weekend show Amaru and I reflected in a mirror shaped like two angel wings cemented on a building wall; my feet and his shadow on vintage red-and-yellow floor tiles; him interacting with the characters in the graffitied walls in the hills. At El Desayunador—a place that no longer exists—we shared a meal of eggs, toast with butter and strawberry jam, and yogurt and berries, which we ate under the huge Loro Coirón black-and-white mural on the restaurant's wall. Chile had the largest and sweetest strawberries we ever tasted, we agreed, a treat we'd miss when we were no longer living in this country. An image I made from this breakfast depicts your grandson sitting against the wall in the restaurant, happy, a flock of pigeons flying above his head on the painted mural.

The photograph I have of myself where I am the happiest was taken by Amaru at the bus terminal on our way back from this trip. I am sitting on the curb, wearing a black-and-white polyester dress—my favorite during those years—a bad instant Nescafé in hand. Sitting next to me is a quiltro, what they call stray dogs in Chile. In the black-and-white picture, the quiltro and I are looking at each other and grinning, his eyes reflecting parts of myself that I'd just begun understanding. In this

exchange, a recognition and acceptance of my propensity to stray, of my deep-seated loneliness, of my overpowering need to always run away from myself.

<center>*</center>

TÍA M AND I TALK on the phone as I chain-smoke menthol Lucky Strikes and pace back and forth outside my lawyer's office in Santiago Centro. It's late November and the seasons are turning; as the winter approaches in Nueva York, Chile begins to warm up. I fill her in with the latest details. Amaru's father won't let us leave and has retaliated by requesting full custody, and now I face the dangers of a justice system completely unknown to me.

"Tía, I don't know what to do. I will die if he takes Amaru away from me."

She is silent for a minute and then tells me, with the same tone she told my cousin M to put me on that flight to Orlando when I was in trouble, "Pues si no se va a poder por las buenas, se va a poder por las malas. Can't you find a way to leave through Argentina?"

In my desperation, I yell at Tía that she's crazy. That I have never done anything illegal and I could go to jail in this foreign country. I ask her to stop making me more nervous and hang up on her.

When I enter my lawyer's office, she tells me she wanted me to come in because she is worried about the outcome of my case. She is a beautiful woman in her early forties who was a police officer for many years before becoming a lawyer. It was her dissatisfaction with the misogyny she experienced in the police department, the lower pay for doing the same job as her male counterparts, the sexual advances, and the blatant undermining of her career advancement that made her change fields to one where she has more agency. Similar to la isla, I am learning that

Chile is grappling with a legacy of violence from a long dictatorship that sought to uphold traditional gender norms through sexual violence and limited educational and employment opportunities for women, while the macho, an imposing obelisk like the ones you find in the cities of Santiago de Chile and Santo Domingo, led the land.

With Amaru's father, I experienced this misogyny a different way, not through sexual violence but through intellectual dominance. A man who talked to me as if he were always educating me. In our co-parenting, his ulterior motive always to convince me to do as he said, to always bend his way. So when I told him Amaru and I were done with Chile, that we missed our family and were struggling in this country, he refused to bend my way, disregarding that one and half years prior, I had moved ten hours away by plane from home so your grandson could be near him. This intellectual dominance is what he wanted to preserve when he tried to force me to endure hours of mediation so we could come to an agreement about leaving, which I knew meant getting us to stay in Chile. But locked inside the walls of this country, of my kitchen darkroom and of the scalding uterus of the temazcal, I had transformed. I now knew that albeit imperfect, we had a home we belonged to. That I had talent and something valuable to pursue that I could no longer put on hold so he could pursue his goals.

My lawyer explains just how deep in shit I am.

She knows the conservative Chilean justice system intimately. She knows the court-appointed experts can be bought and for how much money. She knows the custody procedures are lengthy in Latin America and that even if I manage to win, the case can be appealed and last years, forcing Amaru to stay longer in Chile, risking the judge seeing a move back to the United States as a detrimental uprooting. It sinks in that how things are unfolding means I can lose my child, that your grandson can

be mandated to stay in Chile, where his father's family, in contrast to ours, is perfect on paper.

Inside her office, I relive the same sensations of the night I gave birth to Amaru, when he was taken from me and I was left alone in the hospital room. I feel the same instinct to act, to protect myself, only now it's heightened because my child is at stake, and I will do anything to ensure I am not separated from him. Tía M's advice now seems like the most plausible option. Just like I did in that hospital room, I start to plead for help in my lawyer's office. Hinting at what Tía told me and gauging what my lawyer is willing to do, I ask her if I have any other options.

"Do you have Amaru's passport in your possession?" she asks me.

I tell her I do, and she gets on her computer and searches for a few minutes. "There is no exit ban for you in the system. I can help you leave, but you need three hundred dollars this afternoon to pay a notary to falsify a parental authorization form for travel," she tells me, looking me straight in the eye. Now she's the one gauging me to see what I'm willing to do. "And you have to leave in twenty-four hours before an exit ban is placed."

I call my cousin M, Tía M's daughter. I don't call Tía because I don't want her fearlessness to cloud my judgment. I want someone to tell me this is crazy and I shouldn't do it. The cigarette burns close to the filter as I wait for my cousin to gather her thoughts. I find myself inside another déjà vu. I am pregnant with Amaru, at a crossroads, asking her to guide me through a very important life decision. It comes to mind that my life is advancing in a loop, a car driving an endless circular road leading me to the same places over and over. To get out, I must carve my own exit.

"What should I do?" I ask my cousin. "I am scared that if I see the case through, he'll take Amaru from me. But I'm also scared of falsifying this document, getting caught, and going to jail in Chile."

More silence. The cigarette filter is now flat underneath my shoe as I take the first menthol drag of a new one. "This is a very personal decision," my cousin says, "and I can't tell you what to do, but let me ask you this: Which option is scarier?"

•

IT'S THURSDAY AFTERNOON, November 26, 2015. Thanksgiving Day in the United States.

In our apartment in Santiago, my body alternates between the dizziness of a rush of blood to the head and the rapid heart palpitations of adrenaline.

My lawyer instructed me not to tell anyone I'm leaving, to prevent people from talking me out of it or making me more nervous. But I call my cousin M and inform her I'm doing it. Having her rooting for me on the other side, I believe, will give me the courage to go through with it.

On my way to pick up Amaru from school, I stop at a toy store and get three packs of Pokémon cards, one for each of the checkpoints at the airport.

After school, Amaru is watching TV in our apartment, lying on the wooden floor in his school uniform with no shoes on. The sunset washes the floor with a silver glow.

In his bedroom, his plush dog lies on its side with its head near the window, bathed in sunlight. These scenes are the last two photographs I take in Chile.

My single piece of luggage holds only the poncho Ana made me, my camera and photo negatives, some of Amaru's favorite books and LEGOs, and two vinyl records, *Las últimas composiciones* by Violeta Parra and *Mientras más lo pienso tú* by Juan Luis Guerra. Everything else stays in the apartment as if I had gone for a walk or to buy marraquetas in the morning. My enlarger on the kitchen counter. The clothes in our closets. The toothbrushes in the white plastic cup in the bathroom. The three volumes of *Cuentos completos* by Julio Cortázar that I bought in El Ateneo in Argentina. Amaru's slippers next to his bed and his plush dog on top of it.

When my lawyer calls me from downstairs, I tell Amaru I have a surprise for him. Since it's Thanksgiving, we are going to pay Tía M

a surprise visit. I emphasize that it is a surprise and that he can't mention it to anybody at the airport.

"We have to leave now," I tell him as I usher him out the door, faking excitement. We don't have time for him to shower, so he leaves in his navy-blue school uniform and black shoes. I grab our passports and my one piece of luggage and take him downstairs to head for the airport. I can't recall if I turned the TV off.

In my lawyer's car, she makes small talk with Amaru as I sit in the front seat, wiping my tears and snot every few seconds with the cuff of my black sweater. I take in the landscape bordering la Autopista Costanera Norte. This twenty-minute car ride from our apartment in Calle Monjitas to the airport, under the purple and blue hues of dusk, is as close to a goodbye as Amaru and I will have to Chile. When we get to the airport, I'm shaking as she hands me the notarized form and tells me, "Breathe. You'll make it. Call me when you pass migration."

At the airport, the dizziness leaves my body and I am now running on pure adrenaline. I feel my heart beat twice its normal pace as I carry out a series of coordinated moves.

I hand our passports to the airline employee and a pack of Pokémon cards to Amaru to prevent him from engaging in conversation. He is excited, tearing open the pack and checking the names, types, weaknesses, and HP of each card.

We arrive at the security checkpoint, and I hand the officer our passports and another sealed pack of cards to Amaru. His eyes widen as he says this is the best day ever. I feel horrible for tricking him.

When we get to the migration checkpoint, I take out the notarized form, inspecting the ink signature and dry seal from the notary, as if I could discern it looks legit. I give our passports and notarized form to the migration officer and the last pack of Pokémon cards to Amaru. My sweater is now wet around its cuffs and drenched under my armpits. He

inspects the documents and fixates on the notarized form for a couple of minutes. Each passing second an eternity. My heart the beating drum in "Arriba quemando el sol" by Violeta Parra. He makes a phone call and leaves the glass cubicle to talk to another officer in the back. I feel the surge coming up my eyes and nostrils as I look at Amaru and fear this is the last day your grandson and I will be able to spend time together freely.

No. I refuse to let this happen.

I inhale, swallow the salty gulp, and shake my head straight. I kneel and hug Amaru. I breathe in his sweet sweaty little-boy scent and gather the courage to distract him one more time: "¡Vamos a ver a Nena!"

The migration officer returns and tells me something is wrong with the notarized form. All my blood rushes to the soles of my feet and back to my head. My right knee buckles as I try to keep a straight face.

"This is the parental authorization form you use for school procedures, not for traveling purposes."

"Thank you for letting me know! I'll ask his father to sign one as soon as we're back. We're visiting our family for Thanksgiving break. We'll be back next week," I reply, the adrenaline keeping my knees locked in place.

Two heartbeats in the span of one. The officer stamps both our passports and says, "Buen viaje."

From my seat on the plane, the sky now a dark blue through the round window, I call my cousin M. "I made it through. See you tomorrow morning at JFK."

When the plane takes off, I grip Amaru's small hand until we are eighteen thousand feet high in the sky and the seat belt sign is off. Then I hug both my knees to my chest and fly the ten hours back home in the fetal position.

FIVE

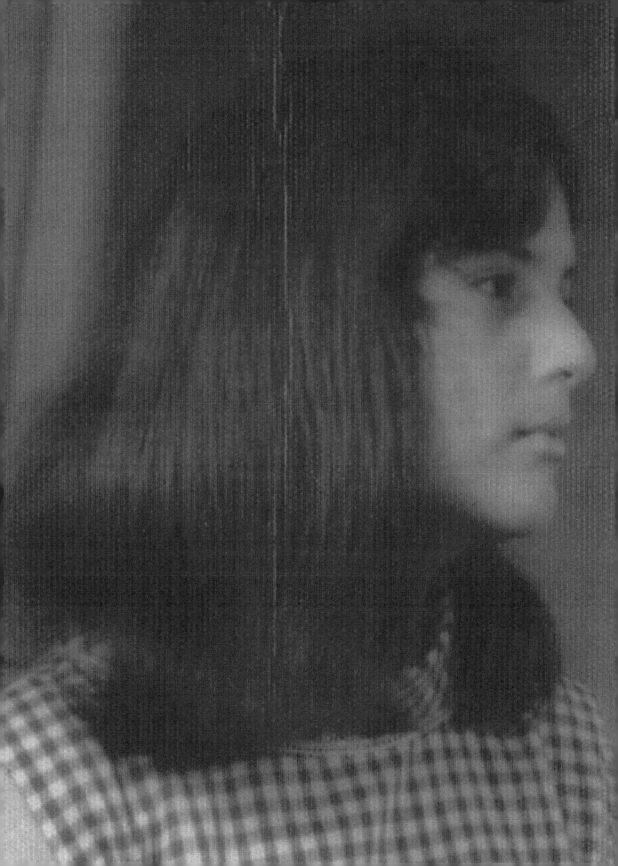

MONSTERA

PETRICHOR. That is the word I find online to describe the smell that greets me when I get off the plane en la isla. The scorching soil cooled down by tropical rain. The scent of the aftermath. After the pandemic, spending in-person time with my closest friends who once lived in my neighborhood in Nueva York or only a few subway stops away now entails traveling to different cities and countries. The ripples of these four years after COVID are visible in my life in a myriad of ways. In the prolonged stretches of time alone at home, in the rounder edges of my body, in the sense of dread every day when I wake up in a world I barely recognize. I watched the complicated city I love so much turn into a ghost town and then a war zone. The quietness in the empty streets was interrupted at 7 p.m. every night as the people in lockdown applauded the health care professionals keeping the overflowing hospitals afloat and its citizens alive. As the Black Lives Matter movement reached its peak, all the businesses on our street were vandalized, Amaru and I startled out of our sleep by glass breaking and people screaming. Due to the unavailability of shelters, the homeless set up camp on several streets in our neighborhood, and from our second-floor window, we could see they were using the sidewalk as a toilet. Nueva York was a pressure cooker, inside and out. Fleeing felt like my only choice.

During my insomnia-fueled nights in Jersey City, sniffing the corners of the kitchen for gas leaks and placing my ear near the electrical panel to detect any abnormal buzzing became as routine as brushing my teeth. After managing to fall asleep, I'd wake up from the thin slumber to check if the gnats I saw earlier on the soil of my potted plants were flying near my mouth. And when I stopped showering for days on end and resorted to spending most of my free time on the couch, I reached

out for help. Inside the travel toiletry bag I've brought on this trip is an orange bottle with the medication the psychiatrist prescribed me. I take out one of the white Prozac pills and place it in the palm of my hand. I remember la muñequita quitapenas a few years back. Maybe this can be my amulet. I put the pill back in the bottle and tell myself I will start the treatment after this trip.

From the balcony of my friend's thirteenth-floor apartment in Juan Dolio, the Caribbean Sea stretches into the horizon, its turquoise waters peaceful from afar, the crashing waves only thin white lines that disappear quickly on the water's surface. Distance, I now understand, can turn the strident force of the ocean into a murmur.

•

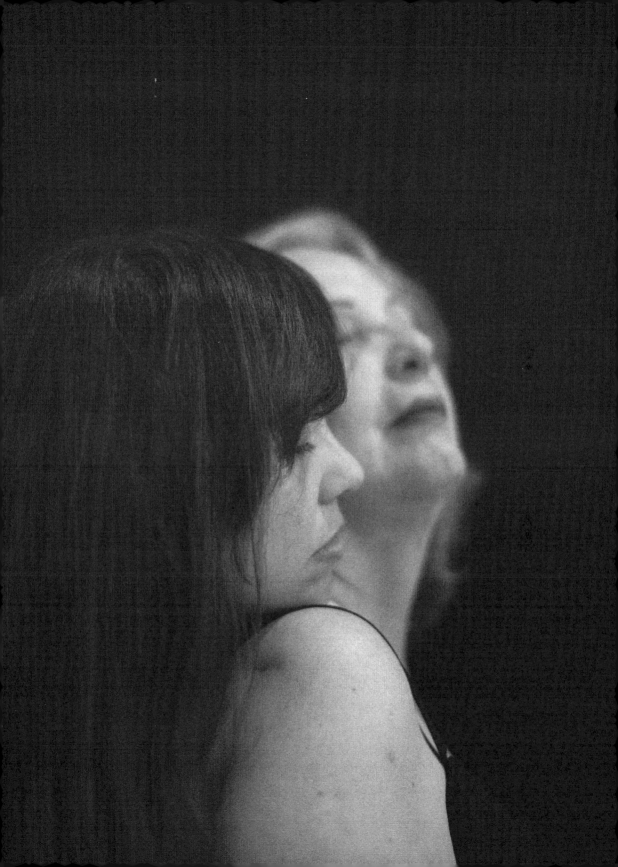

YOU AND I TRAVEL to Santiago after my brother's accident. It's 2018 and we haven't been there together since I was eleven years old, before you moved us to la capital where H lived. My birth city looks smaller than I remember, as if its topography has shrunk and become flat overnight. The hemorrhaging has stopped, the doctor says, but you keep crying. I feel like hugging you, but I don't.

My cousin Y lets us stay in her son's bedroom, which has a plush queen bed. Maybe it is the tiredness from all the hours sitting on the plastic hospital chairs or our shared fear of losing my brother, but we ease into an unexpected conversation.

"Quiero decirte lo que no me gusta de ti," you say. "You are an inconsistent person; I never know what you like or who you are. You used to like flower dresses and wear them all the time. Now when I send you something with flowers, you never wear it. You say you do, but your aunt told me you give them away or resell them. Now you only dress in black, like you're headed to a funeral. You also never call or tell your son to call me. You don't treat me like I am your mother."

I am hesitant, but I allow you to see the part of me that longs for you. "You never said you loved me, hugged me, or kissed me. How do you expect me to be close to you?"

Your self-awareness surprises me when you explain you were never hugged or kissed either, that you are sixty-eight years old and it's too late for you to change.

The next morning, as we both get ready to go to the hospital, I lie in bed waiting for you to get out of the shower. You come out of the bathroom naked, your white skin and grayish-blonde hair still dripping water. I haven't seen you naked in a long time. I realize I have avoided looking at you since I notice now that you have a slight limp in your stride. You approach the bed and get on top of me, transferring the water from your naked body to my clothes. You throw your arms around me

and kiss my face and my neck roughly. "¡Ahí están tus besos!" you say as you keep kissing my pinned-down body. It feels like a hundred chickens are pecking at my face.

I leave la isla feeling like something has shifted. An acceptance that you will never be the warm mother I need, and I will never be the tough daughter you wish for. We spoke our truths, and in doing so, we grieved the relationship we can never have. But now, isolated at home, watching the pandemic ravish families and take away their loved ones, I ache for your icy embrace. I feel like taking an impromptu flight from Newark to Miami to see you, but I can't since you have high blood pressure and my traveling there could put your life at risk. Your newfound fragility and the state of the world soften my grudges and remind me that, unlike you, it's not too late for me to change.

●

IT'S 7 A.M., the time my remote job starts, and I allow myself two heaping teaspoons of sugar in my Colombian coffee. At thirty-eight, it takes my body only a few days of these indulgences to start expanding around the waistline, but I put my insecurities aside and treat myself the week I visit you. The fanciest strobe can't compete with the Florida sunlight during early morning. The soft, balmy light travels along the white walls as I sip my coffee, bathing them in a golden hue. I open the glass sliding doors to the backyard and let the humid air warm the air-conditioned rooms in your house. The spartan interior of your home, decorated only with the most basic furniture and not a single ornament, assures me that during these years we've been apart, something inside you has evolved.

Since we started speaking again, in my head, I keep seeing a photograph of me resting my head on your lap and you caressing my hair. This is not only a new image in our relationship but a new way of image-making in my work. Accustomed to the thrill of photographing the

street and documenting the fast-paced life of raising a young child, up to this moment my photography has been anchored in dissecting the decisive moment in my surroundings, in being surprised by what chance can bring to a photograph. Composing this image of us beforehand, in my imagination, indicates to me that something in my artistic practice is also evolving. Deepening. Your backyard is bare, except for two dilapidated chairs in a corner. The dark wood in the chair legs and frame is discolored from water damage, the black pleather upholstery flaking away. Seeped into their wonky structure, countless days of heavy rain, several tropical storms. The slap-slap of your plastic flip-flops against the tile floor gets louder as you approach the backyard. Your thinning hair is disheveled and dyed a rich brown, a color I prefer because it makes us look more alike.

"Hola, Mami," I ask you without hesitation, "¿quieres tomarte una foto conmigo?"

●

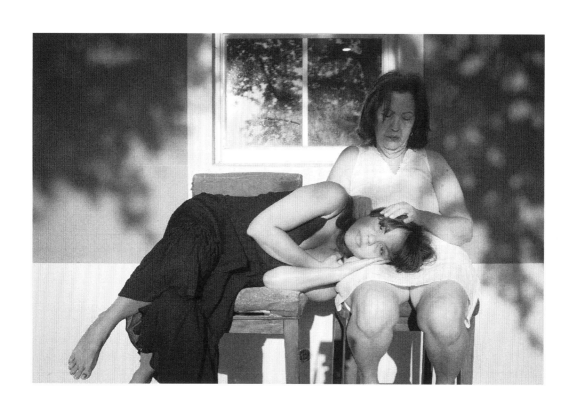

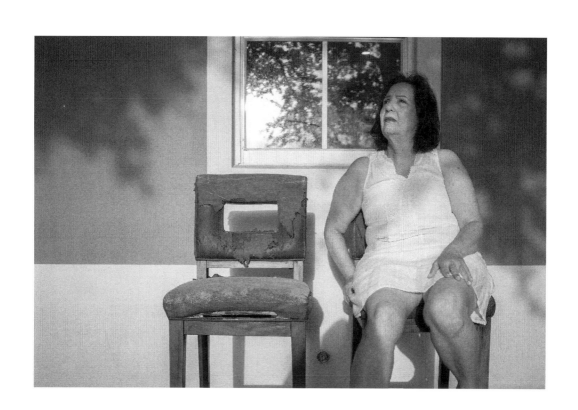

IN A SOUTH-FACING WINDOW of my first apartment in Jersey City, the one Amaru and I lived in before purchasing our current one, I kept the wilted and yellowing monstera plant leaves. We were walking on 88th Street on our way to Ross, your favorite store, to find cheap dresses. You lost weight during the pandemic, so we scoured the same rack of size eight dresses, me preferring black ones with simple cuts and you opting for incandescent reds and oranges. Bright colors look so beautiful on you. We were the only people walking on the sidewalk of this main avenue in Miami, cars roaring past us on the left, and on the right, thick bushes of wild monstera plants.

I tell you that I love plants and have many of them at home, to which you reply that you don't want anything that requires care in your house: "No quiero matas, ni animales, ni tampoco muchachos jodiendo." I joke and tell you that God has punished you by giving you eight grandchildren, the most out of your three sisters.

As we walk, another image appears in my head: you resting on the fertile Florida soil, ensnared by giant tropical plants. The pink pleated dress you are wearing is nice and I'd hate for it to get dirty, but I am already reaching for my point-and-shoot camera strapped across my chest, ready to stage this photo. You love being photographed and indulge me. We take a few steps into the bushes. I help you first to your knees and then to your back until you are horizontal on the ground. Your face is framed by large Swiss cheese leaves, and I take smaller dried ones from the ground and adorn your legs with them. I stand up to take a zenithal shot, and my long black dress flutters in the lower part of the frame as you rest pallid on the ground in your bright pink one. It is only when I print this photograph later at home that I realize it looks like a burial.

Every day during my visit, we take an early morning walk around your neighborhood in Kendall. The sterile uniformity of the houses and manicured lawns brings a sense of orderliness to our walks, a comforting

predictability to our time together. Back in the house, when I sit in front of the computer to start combing through dozens of work emails, you bring me a large cup of café con leche. I can taste the nutmeg you grated into the ground coffee before you brewed it. Floating on its steamy surface are a couple of ants that made their way into the crystal bowl of white sugar you have on the kitchen counter. The ants eluding your worsening eyesight and now floating on my coffee are tangible evidence of the passage of time on your body, of the vulnerability that comes with age.

"¿Cómo está el café?" you ask.

I take a hefty sip and swallow both ants. "Mami, está riquísimo."

On my last day in Miami, I wake up to find you aren't home. A few minutes later, you arrive holding three medium-sized monstera leaves, their tentacled roots still covered in soil.

"Para tu casa," you say, placing them in a clear glass of water in the kitchen window. You listened.

Before I leave for the airport—the monstera plant inside my hand luggage wrapped in a Publix plastic bag and padded by the dresses we purchased at Ross—you approach the Uber to give me a hug. Your eyes blink rapidly, your chin trembles, and you open your arms so that your hands barely touch the lower part of my back. A lukewarm hug to the lay onlooker, but to us, a milestone. The young armor inside me cracks wide open.

<div align="center">◉</div>

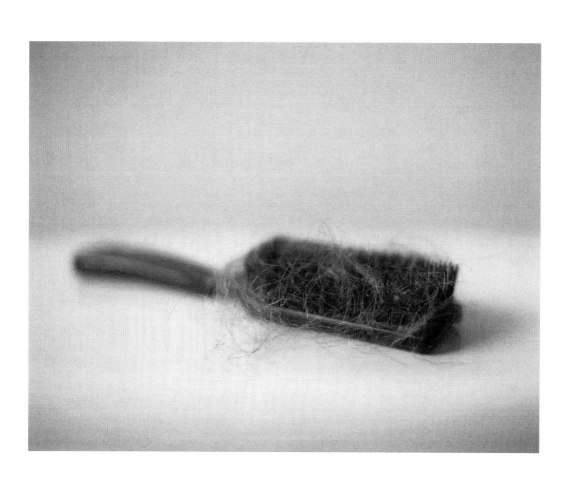

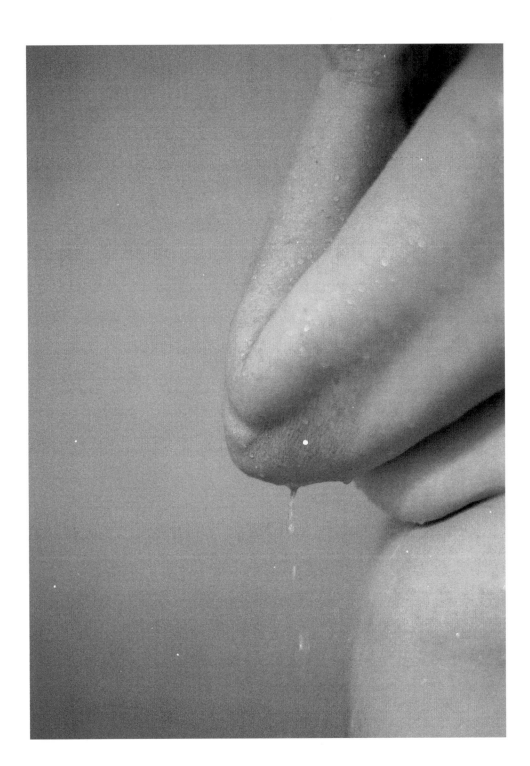

IN THE BACK OF A MOTOCONCHO, I'm already savoring the mangú con huevo y queso frito that I've been craving since I got to la isla. The motorbike is an older model that rattles, and I feel my flip-flops warming up from the heat of the muffler near my legs. The dusty road is filled with pot-holes, so I ride the ten minutes to the restaurant with my arms wrapped around the driver's waist. Just like my Uber driver in Jersey City, my motoconchista is Haitian, his Spanish thick with a Creole accent. In the Caribbean heat, you expect the acrid smell of perspiration in the forced closeness of a motoconcho, of a voladora. But what the breeze pushes from his body to my face during this ride is musk. It's the woody scent of the incense they burn at church. It's the spiced aroma of the Maja dust-ing powder you loved during my childhood. Lifting its white puff by the ribbon bow and smelling the hints of patchouli, rose, and geranium in the loose powder was how I hugged you, how I discovered your smell. Today, I'm still unable to embrace anyone without their scent triggering the memory of yours.

In the rearview mirror of the motorcycle, a fragment of my image is reflected back to me. The deep creases between my eyebrows, a small part of my suntanned shoulder, my curly hair steeped in ocean water. This trip back to la isla seemed necessary to revisit our history, to finally take you outside of me and place you in these words, on these pages. Embodying the feelings that arise when I set foot in my motherland might afford me the courage to accept the insurmountable void you left in your wake. The depression I suppressed for decades as a way of sur-vival, as a way to rebel and not let you win. The inexorable fact that you are unable to be a mother.

•

IN THE MONTHS AFTER my trip to Miami, you love-bomb me with a flurry of gifts. You mail me cloying rose-scented perfumes, bags of salted caramel coffee you found on sale, and always some version of flowered cotton pajamas. Your gifts are followed by a phone call. "Mi hija, did you like the pajamas? Don't give them away! If I find out you gave them away, I will be mad at you!" you tell me, your scolding reassuring in these days of isolation. The new pajamas smell of Nueva York, the same way our gifts smelled when my aunts opened their suitcases when they visited us en la isla. A mixture of Downy and cheap pharmacy candy. On my window, the three yellowing monstera leaves—which I repotted twice to accommodate the growing roots—die and give way to waxy, electric-green new leaves. This mound of soil and chlorophyll, I believe, is a living, breathing testament to our budding relationship. I gush about you and me to a good friend of mine, and she tells me to be cautious. I assure her this time things are different.

The exact moment when things between us begin to sour eludes me, but I recall an omen. The January day we moved to our current apartment, my dozen plants, including the one you gave me, froze solid inside the moving truck. After they thawed, only the peace lily survived. The leaves of yours darkened as they thawed, then turned to mush and fell off. What remained were the stubs attached to the roots, which I placed in water by a luminous window, hoping new leaves would sprout.

As this new home starts unsettling me, I confide in you. You reprimand me for being so ungrateful. Your gifts and calls become more sporadic. I tell you that I miss you and would like to visit you. You don't seem excited on the other end of the phone but tell me to come anyway.

When Amaru and I arrive at your house, I feel I am greeting a completely different person. Your hair is bleach-blonde again and you have gained some weight. You show us to the bedroom, and the mattress on the bed is naked, the bedsheets folded on top of it. "You can make your

own bed. I'm too old to be doing these things for visitors," you say. In the kitchen, you heat up some leftovers and tell us that food is ready before retreating to your bedroom. Amaru and I eat alone in the dining room.

The next morning, I ask if I can take a photograph of you and Amaru since I don't have any. We step into the backyard, your grandson fresh out of bed, shirtless and still groggy. I continue following my hunch of making photographs this way and stage the shot. I place him in front of you and ask you to hug him from behind, one of your hands skin to skin, dead center on his chest. Both of you can only endure a few minutes of faked intimacy.

Craving more mother–daughter moments, I ask you to teach me how to make dulce de leche cortada, a Dominican dessert that I love. Whole milk, sugar, limes, raisins, vanilla, and cinnamon are all you need to make it. We pour a gallon of milk into a deep aluminum pot and let it boil. You stare me up and down as I'm juicing the limes, saying, "I think is time for you to get surgery on your boobs. They are too big and saggy." I lie and tell you that I like my breasts just as they are. As I try to open one of the little red boxes of raisins, they fall on the floor, and you raise your hand and yell, "¡Muchacha de la mierda tan regueretosa!" I recoil as you pour lime juice over the milk and we watch it curdle in silence.

You spend more time in your room than with me during the long weekend we are there. I hop into your bed and ask what you are watching on Telemundo. You ask me not to distract you from the presenter's commentary. I sink into the pillow and rack my brain to figure out what I did to cause your distance. During one of the commercial breaks, I hear you chuckling and ask what you are laughing about. Your laugh is so strident, so intoxicating, I begin laughing before getting the answer from you.

"Remember when you cooked that rice that made everyone sick at your cousin M's wedding?" you tell me.

I am puzzled by your comment since people got sick at her wedding from a seafood dish that was left out in the sun for too long.

"Mami, I think you are confused. It wasn't my rice that made people sick, it was the shrimp salad."

"Yes, it was! Yes, it was!" you shout as you point your index finger at my face, your eyes like saucers. You are laughing and choking.

"It's the rice with saffron, raisins, and almonds that you like. You called to ask me for the recipe, remember? But I gave you the wrong recipe, de maldad. I told you to use twice as much water, and...and..."—you have a hard time completing your sentence because you are laughing so hard— "and when you complained that it was coming out too mushy, I told you to add more water. It was YOUR RICE that made everyone sick."

There's a spark in your eyes, a joy and aliveness that I can't fathom comes from humiliating me. The cinder block on my chest again. The moment my friend tried to warn me about. I realize the two photos I made of you embracing me and your grandson are not documents of a new relationship but a product of my imagination.

When I come back home, the dial on my albuterol sulfate pump goes from a hundred to zero in a week. When I am not wheezing, I am crying. Coni assures me I did nothing wrong by opening up to you, but I am angry at myself. Maldito corazón de pollo, sensibilidad de mierda. I go to the kitchen, take the leafless, moldy monstera roots out of the water, and throw them in the trash.

●

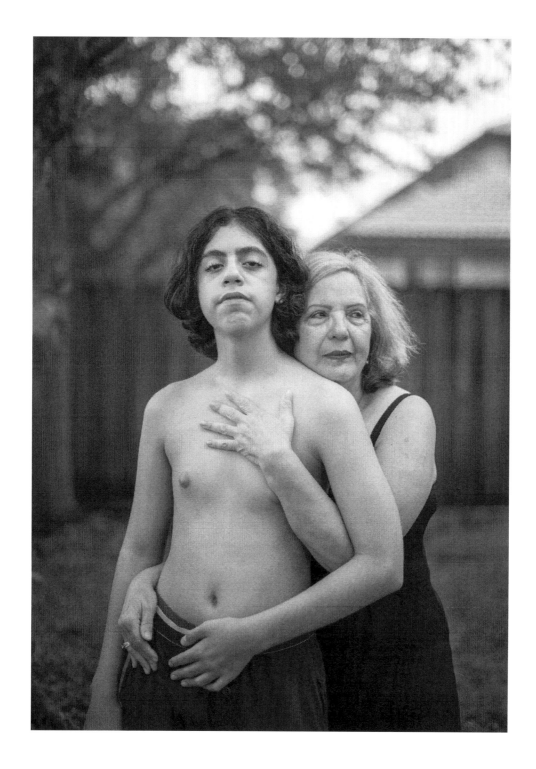

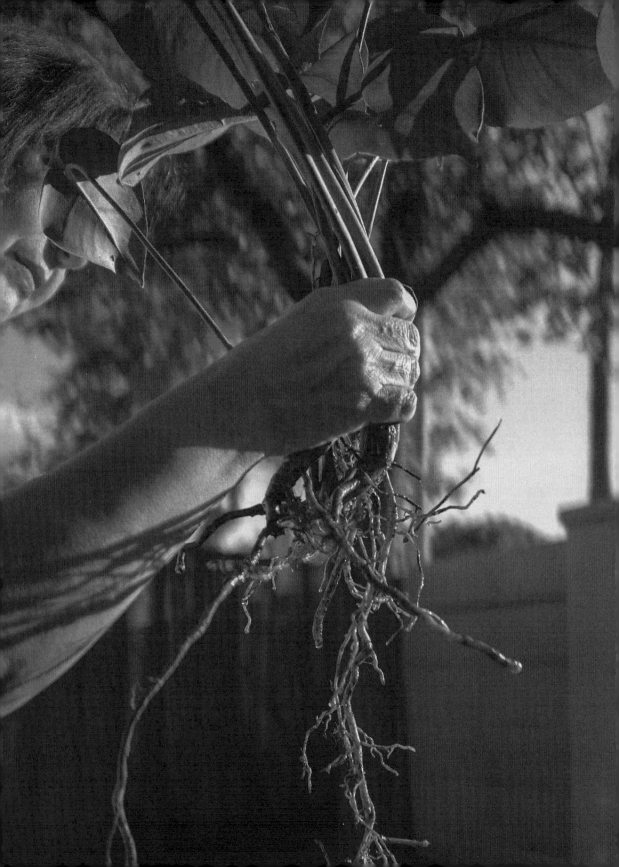

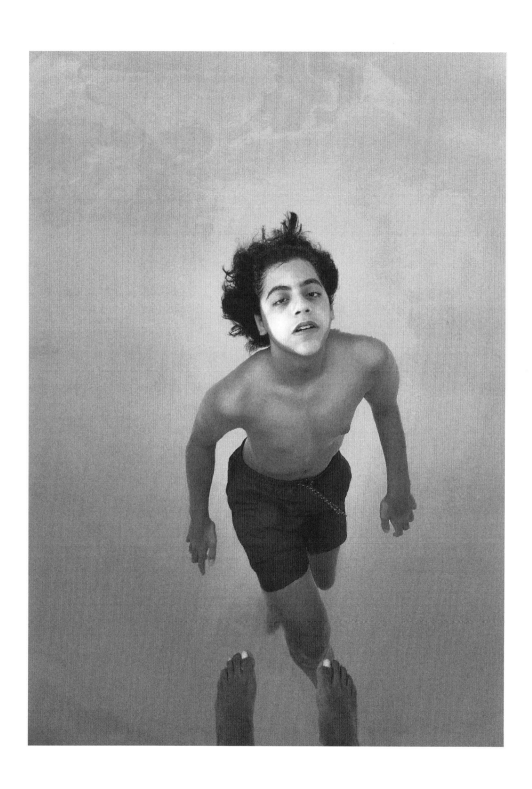

THE SHORELINE IN Juan Dolio is littered with pieces of broken glass being shuffled back and forth by the waves. I pick one up and see it's no longer see-through. Its surface is opaque, and its edges have been softened by the constant brushing against the sand. Time can smooth the sharp edges of anything but can also deem it unrecognizable. I hold the cloudy glass fragment as I walk along the water and repeat the mantra Coni and I have practiced: "My feelings are valid. I allow myself to feel this anger and this sadness." Uttering these words immediately triggers my guilt. Mala hija. So I recur to the other mantra we've practiced: "Dejo ir la culpa y sigo adelante aunque no sepa cómo."

La culpa. The reason why writing this letter to you has taken four years, why the names of everyone in our family in these pages have been reduced to only letters. Abuela and Tío, E and A, the first two vowels of the alphabet, the beginning of this story.

I started revisiting my diaries after the last trip to Miami to see you, as I do in those instances when I stop recognizing myself. During my preteen and teenage years, my diaries were filled with lists of ways I could improve myself: Sentarme más derecha. Siempre tener un cepillo de pelo en mi mochila. No hablar tanto, ser más misteriosa. But this time I was not reading my sense of inadequacy in the words but looking at my handwriting. My penmanship was boxy and uniform, with little space between the letters, like small sausages stuffed in a can. The pressure of the pen against the paper was so hard I could trace the letters with my fingers on the back of the pages. My anger was dormant yet already visible in these indentations on the paper, waiting to find the language to allow it into existence.

Years of therapy have helped me dispose of the mythology that the "curse" of our family and its many tragedies was inevitable, a fault etched into each of us, passed down from generation to generation. The truth is, you and your generation are the children of long and bloody

dictatorships. Of strict parents whose hit of the hand was their lexicon. Of a secretive society that punished those who transgressed the golden rule of silence. Your grandson's generation, on the contrary, came out of the womb light, already free of this baggage. They were born with language and agency already at their fingertips. Separating both generations, these pages. My way to break the chain but also, by writing them in a foreign tongue, a kind of self-exile.

En este mar que me vio nacer, I make a series of black-and-white images of the backlit waves at sunset, their turquoise color now a black liquid inside my camera, rhythmically absorbed into the sand. Soft transparent ones, foamy ones carrying rocks and seaweed, roaring ones that make me lose my balance. In my head, I start making diptychs of these images of the Caribbean Sea and the black-and-white studio portraits from your youth, the waves expressing much more eloquently than my words the unpredictability in your character.

I point my camera at the waning sun but forget to adjust the exposure. The image captured is a blinding halo of light, a blank canvas, an endless expanse of white before me.

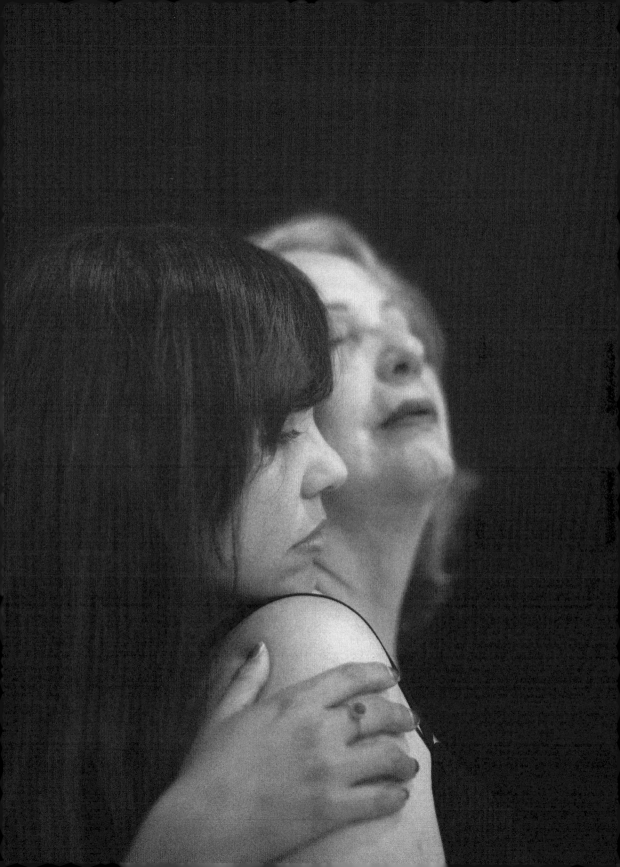

ARAÑITAS

I GATHER ALL THE INGREDIENTS and place them on the countertop in my kitchen. The eggs and the yucca produce elongated shadows in the late afternoon sun. I make a lengthwise incision in the tough yucca, careful not to rip a chunk of it, instead inserting the knife underneath the skin softly so it can come off in one piece, like a tube of bark. I saw you do this in our house in Santiago with such ease that you'd think yucca skin was soft like a mango's. It takes more effort on my part to do something that comes so naturally to you. I shred the yucca on the bigger holes of the shredder, and it becomes a mound of milky tendrils in a bowl. I salt it until, when I put my finger on it, it's the same saltiness of the ocean, of the water in Sosúa. The tough, dark eggplant skin has begun to rupture in the fire on the stove, steam releasing from its seams. I turn the charred side up and keep turning it every few minutes until all the skin is black and brittle. My kitchen smells of embers turning to ash. As the eggplant cools, I look outside the window and examine the building in construction behind mine. It's flanked by a wide, bare tree several feet taller than it, a tree that, if sawn in half, would reveal at least a hundred years' worth of rings in its trunk, the span of three generations. They are using cheap materials to construct the building. Its walls are made of compressed wood, blue Tyvek, and pale gray vinyl siding. I stare at it from inside mine, erected in 1905, using bricks, real plaster, and thick wooden beams between the floors. I am intrigued by the families who lived in this apartment before me and called it home, by the people who more than a century ago also stared at this naked tree from this window in the dead of winter.

As I strip the charred skin from the eggplant, I realize it's been weeks since I put my ear to the electrical panel in the kitchen, since I stood

here paralyzed, fearing the lights would flicker or the electrical breakers sizzle. I add the silky smoked eggplant to the shredded yucca, crack two eggs in the bowl, and sprinkle it with anise seeds and a pinch of sugar. I mix everything with my bare hands. If you were here, I'd ask you if it's the right consistency. I think I put too much eggplant, and the arañitas might not hold their shape. I improvise and add a bit of flour—although this was not in your original recipe—until the mixture feels right and steady in my hand. What I lack in experience, I make up for with instinct.

I know the oil is ready because I drop a tendril of yucca in the pan and it starts to bubble. I make the patties, small mounds that fit in the concave space of my cupped hand. I place a few in the hot oil on medium-high for the first few seconds, and then lower the heat to medium-low for a couple of minutes, your trick to ensure they have good color on the outside but still cook through inside. By the time the last ones are fried, the sun has already set behind the building in construction, my kitchen awash only with the muted light of dusk.

I start eating the arañitas immediately, my tongue and the tips of my fingers on fire. The outside is crunchy and not too oily, and the inside is soft and seasoned to perfection, the right combination of salt, smoke, and anise. You'd be proud of me; they are almost as good as yours. The yucca legs are brown and crispy, and inside they're warm and delicious. A perfect bird's nest.

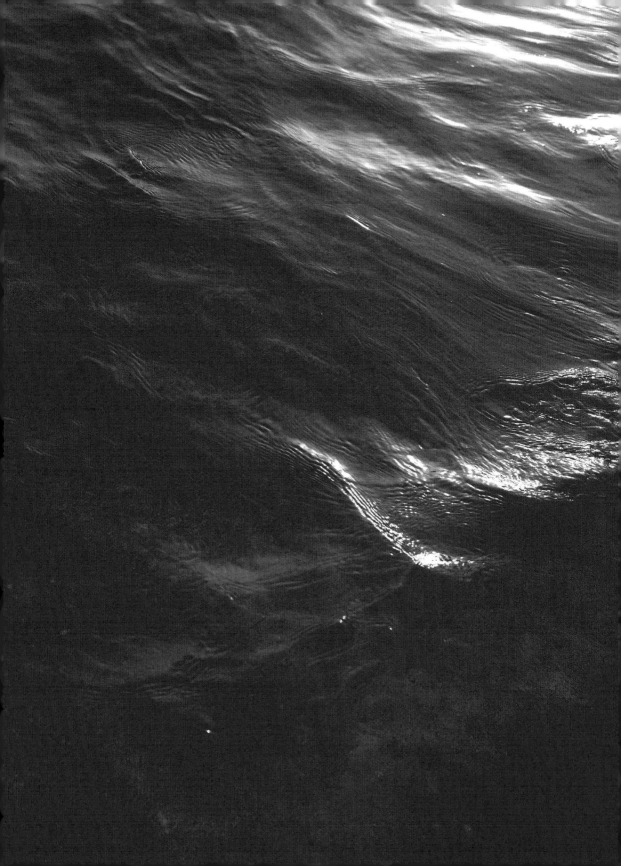

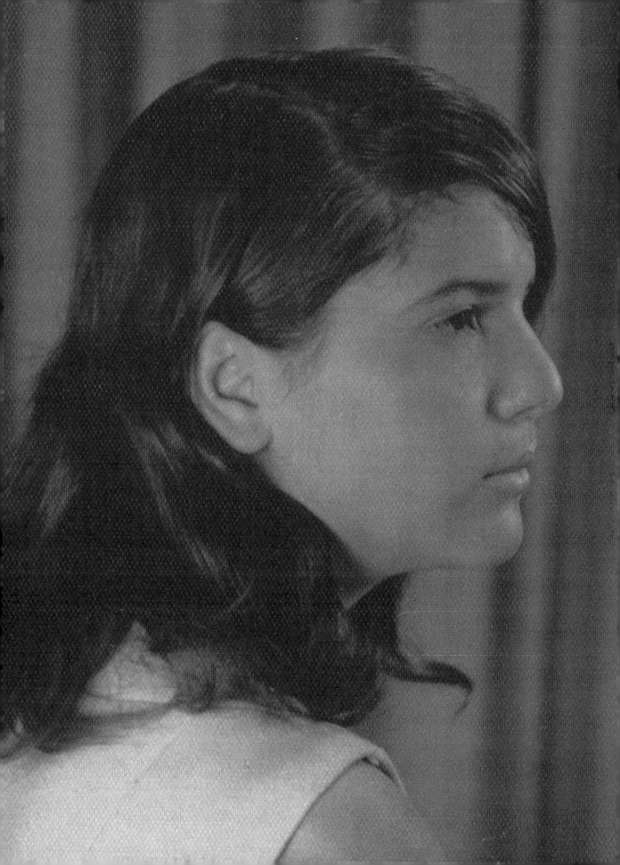

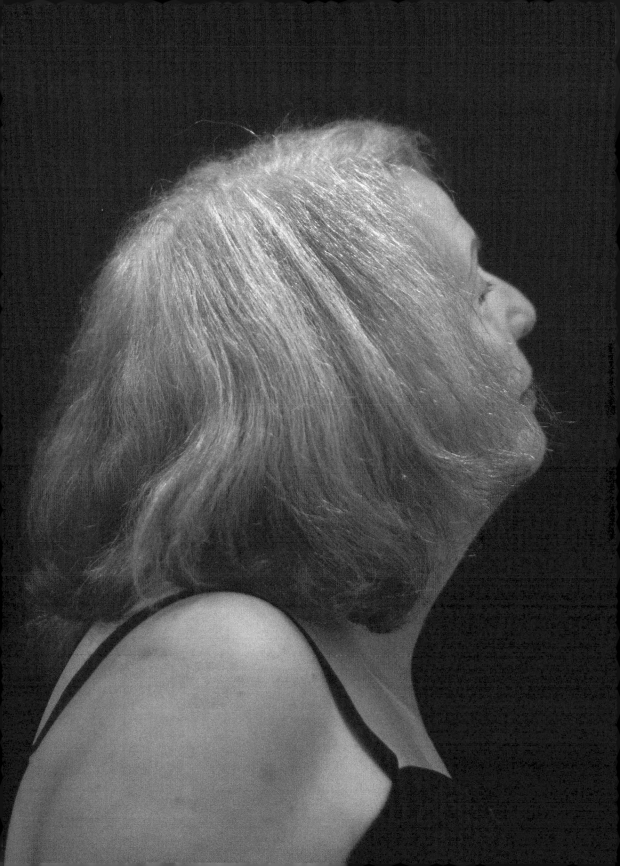

ACKNOWLEDGMENTS

I am deeply thankful to the friends and family who spent time with my words and images and provided valuable feedback—Jennifer, Elizabeth, Mañe. Thank you to John Rufo, an early reader of this work, whose close reading and encouragement helped me to complete this book. To Jaime Álvarez, who helped with research at Archivo General de la Nación in the Dominican Republic for news clippings on my father's disappearance. To Lorenzo Gómez, who shared anecdotes, historical facts, and political information about la isla that helped enrich this work. My gratitude to the Image Text Ithaca program and the Sackett Street Writers workshop, where the ideas for this book started to crystallize. Lastly, my deepest gratitude to my son, Amaru, thoughtful reader and proofreader extraordinaire, who reads every single word I write before anyone else.